Composition

Understanding Line, Notan and Color

Arthur Wesley Dow

DOVER PUBLICATIONS, INC.
Mineola, New York

Bibliographical Note

This Dover edition, first published in 2007, is an unabridged republication of the ninth edition—revised and enlarged with new illustrations and color plates—originally published in 1920 by Doubleday, Page & Company, New York, under the title *Composition: A Series of Exercises in Art Structure for the Use of Students and Teachers*. The first edition was published in 1899 by J.M. Bowles, Boston.

The only significant alteration for the Dover reprint consists in reproducing all the color illustrations in black and white in their original positions in the book, as well as in a full-color insert facing page 58. Regrettably, some of the handwritten captions on the plates in the original were nearly illegible; with one exception (page 30), they are reproduced here as is.

Library of Congress Cataloging-in-Publication Data

Dow, Arthur W. (Arthur Wesley), 1857–1922.
 Composition : understanding line, notan and color / Arthur Wesley Dow.
 p. cm.
 Originally published: 9th ed. New York : Doubleday, Page & Co., 1920.
 ISBN-13: 978-0-486-46007-9
 ISBN-10: 0-486-46007-X
 1. Composition (Art) 2. Drawing—Technique. I. Title.

NC740.D7 2007
741.2—dc22

2007014042

Manufactured in the United States by RR Donnelley
46007X06 2016
www.doverpublications.com

ACKNOWLEDGMENTS

Note.— The author gratefully acknowledges the courtesy of those named below in according him permission to use photographs of certain paintings and objects of art as illustrations for this book.

Museum of Fine Arts, Boston
Metropolitan Museum, New York
The National Gallery, London
Musée de Cluny, Paris (J. Leroy, photographer)
Musée de Sculpture Comparée, Paris
Dr. William Sturgis Bigelow, Boston (permission to photograph Japanese paintings)
Mr. Frederick W. Gookin (use of photographs from Kenzan and Kano Gyokuraku, made specially for Mr. Gookin, Boston M. F. A.
Giacomo Brogi, Florence
Fratelli Alinari, Florence
D. Anderson, Rome
W. A. Mansell & Co., London
F. Rothier, Reims, France, and
Kaltenbacher, Amiens, France (the Ruskin photographer)

License to use photographs was also obtained from the Autotype Fine Art Company, Limited, London (the Michelangelo drawing, page 51), and from Baldwin Coolidge, Boston.

CONTENTS*

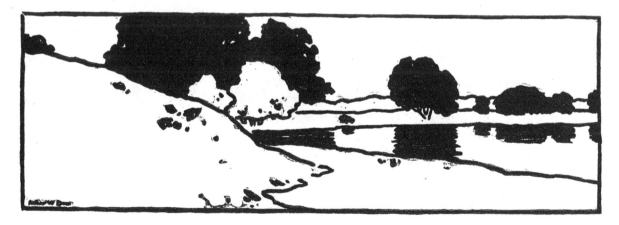

BEGINNINGS

IN writing this book my main purpose is to set forth a way of thinking about art. The most that such a book can do is to direct the thoughts, awaken a sense of power and point to ways of controlling it.

The principles of art teaching here outlined might be illustrated in other ways and with better examples. I hope the reader will see how each chapter can be developed into many sets of lessons. The progressions can be varied, materials changed, lessons amplified and different designs chosen, providing there is no sacrifice of essentials.

The book is based upon my experience in painting and teaching for more than twenty years. The first edition of Composition was published in 1899. In this revision I have made many additions and used new illustrations without departing from theory or principles.

Composition was chosen as a title because that word expresses the idea upon which the method here presented is founded — the "putting together" of lines, masses and colors to make a harmony. Design, understood in its broad sense, is a better word, but popular usage has restricted it to decoration.

Composition, building up of harmony, is the fundamental process in all the fine arts. I hold that art should be approached through composition rather than through imitative drawing. The many different acts and processes combined in a work of art may be attacked and mastered one by one, and thereby a power gained to handle them unconsciously when they must be used together. If a few elements can be united harmoniously, a step has been taken toward further creation.

Only through the appreciations does the composer recognize a harmony. Hence the effort to find art-structure resolves itself into a development of appreciation. This faculty is a common human possession but may remain inactive. A way must be found to lay hold upon it and cause it to grow. A natural method is that of exercises in progressive order, first building up very simple harmonies, then proceeding on to the highest forms of composition. Such a method of study includes all kinds of drawing, design and painting. It offers a means of training for the creative artist, for the teacher or for one who studies art for the sake of culture.

This approach to art through Structure is absolutely opposed to the time-honored approach through Imitation. For a great while we have been teaching art through imitation — of nature and the "historic styles" — leaving structure to take care of itself; gathering knowl-

edge of facts but acquiring little power to use them. This is why so much modern painting is but picture-writing; only story-telling, not art; and so much architecture and decoration only dead copies of conventional motives.

Good drawing results from trained judgment, not from the making of fac-similes or maps. Train the judgment, and ability to draw grows naturally. Schools that follow the imitative or academic way regard drawing as a preparation for design, whereas the very opposite is the logical order — design a preparation for drawing.

Soon after the time of Leonardo da Vinci art education was classified into Representative (imitative), and Decorative, with separate schools for each — a serious mistake which has resulted in loss of public appreciation. Painting, which is essentially a rhythmic harmony of colored spaces, became sculptural, an imitation of modelling. Decoration became trivial, a lifeless copying of styles. The true relation between design and representation was lost.

This error is long-lived. An infinite amount of time is wasted in misdirected effort because tradition has a strong hold, and because artists who have never made a study of education keep to old ruts when they teach.

This academic system of art-study ignores fundamental structure, hence the young pupil understands but few phases of art. Confronted with a Japanese ink painting, a fresco by Giotto or a Gothic statue he is unable to recognize their art value. Indeed he may prefer modern clever nature-imitation to imaginative work of any period.

Study of composition of Line, Mass and Color leads to appreciation of all forms of art and of the beauty of nature. Drawing of natural objects then becomes a language of expression. They are drawn because they are beautiful or because they are to be used in some art work. Facility in drawing will come more quickly in this way than by a dull routine of imitation with no definite end in view.

The history of this structural system of art teaching may be stated in a few words; and here I am given the opportunity to express my indebtedness to one whose voice is now silent.

An experience of five years in the French schools left me thoroughly dissatisfied with academic theory. In a search for something more vital I began a comparative study of the art of all nations and epochs. While pursuing an investigation of Oriental painting and design at the Boston Museum of Fine Arts I met the late Professor Ernest F. Fenollosa. He was then in charge of the Japanese collections, a considerable portion of which had been gathered by him in Japan. He was a philosopher and logician gifted with a brilliant mind of great analytical power. This, with rare appreciation, gave him an insight into the nature of fine art such as few ever attain.

4

As imperial art commissioner for the Japanese government he had exceptional opportunities for a critical knowledge of both Eastern and Western art. He at once gave me his cordial support in my quest, for he also felt the inadequacy of modern art teaching. He vigorously advocated a radically different idea, based as in music, upon synthetic principles. He believed music to be, in a sense, the key to the other fine arts, since its essence is pure beauty; that space art may be called " visual music ", and may be studied and criticised from this point of view. Convinced that this new conception was a more reasonable approach to art, I gave much time to preparing with Professor Fenollosa a progressive series of synthetic exercises. My first experiment in applying these in teaching was made in 1889 in my Boston classes, with Professor Fenollosa as lecturer on the philosophy and history of art. The results of the work thus begun attracted the attention of some educators, notably Mr. Frederic B. Pratt, of that great institution where a father's vision has been given form by the sons. Through his personal interest and confidence in these structural principles, a larger opportunity was offered in the art department of Pratt Institute, Brooklyn. Here during various periods, I had charge of classes in life drawing, painting, design and normal art; also of a course for Kindergarten teachers. Professor Fenollosa continued his lectures during the first year. The growth of the work and its influence upon art teaching are now well known.

In 1900 I established the Summer School at Ipswich, Massachusetts, for the purpose of obtaining a better knowledge of the relation of art to handicraft and manual training. Composition of line, mass and color was applied to design, landscape and very simple hand work in metal, wood-block printing and textiles. Parts of 1903 and '04 were spent in Japan, India and Egypt observing the native crafts and gathering illustrative material.

In 1904 I became director of fine arts in Teachers College, Columbia University, New York. The art courses are now arranged in progressive series of synthetic exercises in line, dark-and-light and color. Composition is made the basis of all work in drawing, painting, designing and modelling — of house decoration and industrial arts — of normal courses and of art training for children.

After twenty years' experience in teaching I find that the principles hold good under varying conditions, and produce results justifying full confidence.

They bring to the student, whether designer, craftsman, sculptor or painter an increase of creative power; to the teacher, all this and an educational theory capable of the widest application.

To all whose loyal support has given impetus and advancement to this work — to the pupils and friends who have so generously furnished examples for illustration — I offer most grateful acknowledgments.

ARTHUR WESLEY DOW
New York, 1912

5

THE THREE ELEMENTS

I. LINE — NOTAN — COLOR

ARCHITECTURE, Sculpture, Painting, Music and Poetry are the principal fine arts. Of these the first three are called Space arts, and take the various forms of arranging, building, constructing, designing, modelling and picture-painting.

In the space arts there are three structural elements with which harmonies may be built up:

1. LINE. The chief element of beauty in architecture, sculpture, metal work, etching, line design and line drawings. Nos. 1, 2, 3, 6, 23, 38.

2. NOTAN. The chief element in illustration, charcoal drawing, mezzotint, Oriental ink painting and architectural light and shade. Nos. 5, 59, 60, 61.

3. COLOR. The chief element in painting, Japanese prints, textile design, stained glass, embroidery, enamelling and pottery decoration. Nos. 8, 9, and Chap. XIV.

Nº 2. LINE — Flying buttresses Chartres Cathedral

The term LINE refers to boundaries of shapes and the interrelations of lines and spaces. Line-beauty means harmony of combined lines or the peculiar quality imparted by special treatment.

The term NOTAN, a Japanese word meaning "dark, light", refers to the quantity of light reflected, or the massing of tones of different values. Notan-beauty means the harmony resulting from the combination of dark and light spaces — whether colored or not — whether in buildings, in pictures, or in nature.

Nº 1. LINE — Iron, XV century

**THE THREE
ELEMENTS
I.—LINE**

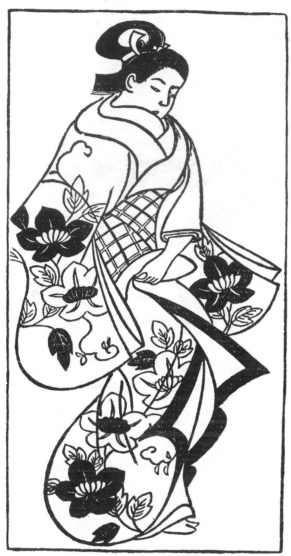

No. 3 LINE. Harmony of rhythmic curves. From book
of prints by Okumura Masanobu, Japanese, 18th century.

Careful distinction should be made be-
tween NOTAN, an element of universal
beauty, and LIGHT AND SHADOW,
a single fact of external nature.
The term COLOR refers to quality of
light.

These three structural elements are in-
timately related. Good color is depend-
ent upon good notan, and that in turn is
dependent upon good spacing. It seems
reasonable then that a study of art should
begin with line. One should learn to
think in terms of line, and be somewhat
familiar with simple spacing before at-
tempting notan or color. There is danger,
however, of losing interest by dwelling
upon one subject too long. Dark-and-
light massing will reveal the mistakes in
spacing and stimulate to renewed effort.
Color will reveal the weakness of dark-

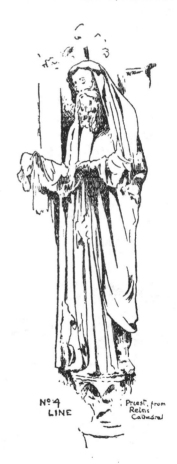

No. 4
LINE Priest, from
 Reims
 Cathedral

8

and-light. Very young pupils should begin with color but the instructor will take pains to include spacing and notan in each lesson. In general, however, the best plan is to take up exercises in each element in turn; then go back to them separately and make more detailed studies; then combine them, proceeding toward advanced compositions. Whatever be the choice of progression, there must be a thorough grounding in the elementary relations of space cutting and simple massings of dark-and-light. This is essential to successful work in designing, drawing, modelling, painting, architecture and the crafts.

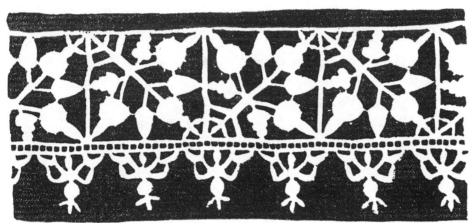

Venetian Lace Two values

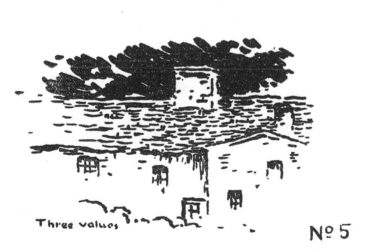

Three values

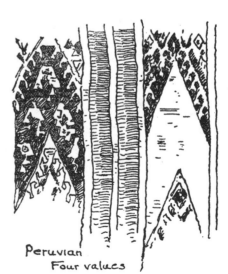

Peruvian
Four values

No 5

9

THE THREE
ELEMENTS
I.—EXAM-
PLES OF
LINE
HARMONY

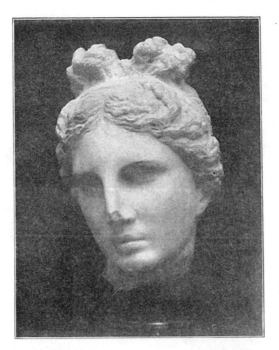

Greek Sculpture
APHRODITE
Museum of Fine Arts, Boston
B. Coolidge, photo.

No. 6

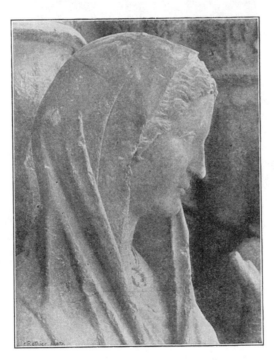

Gothic Sculpture
MARY
Cathedral of Reims,
" The Visitation " group

II

**THE THREE
ELEMENTS
I.—EXAM-
PLES OF
LINE AND
NOTAN HAR-
MONY**

MICHELANGELO

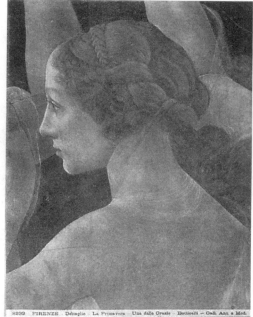

BOTTICELLI

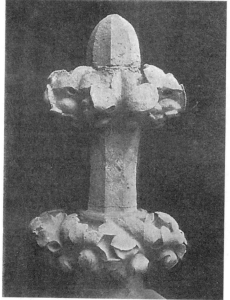

Gothic finial CHARTRES Cathedral

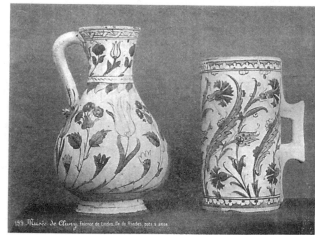

RHODIAN Ware Cluny Museum Paris

12

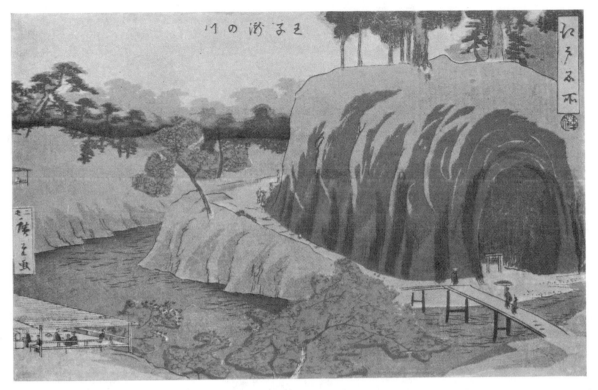

No. 8. HIROSHIGE "Taki no gawa at Oji"

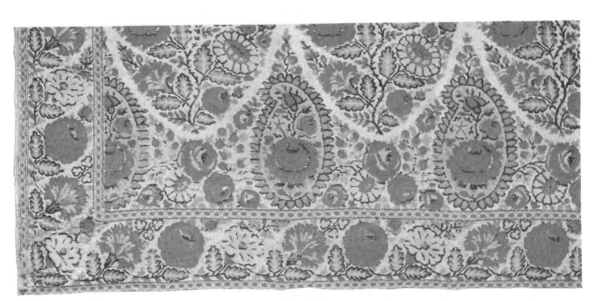

No. 9. Persian woolen, ancient

LINE DRAWING

II.—JAPANESE MATERIALS AND BRUSH PRACTICE

JAPANESE brushes, ink and paper are to be preferred for exercises in line drawing, tracing, notan massing and washes in grays.

Long brushes are best for long continuous lines, short brushes for sharp corners and broken lines. For lettering, clip the point of a long line-brush. (see p. 55)

prepared with a sizing of glue and alum. Unprinted wall paper (lining paper) is serviceable for practice work. "Bogus" paper and cover papers can also be used for line or mass.

Japanese ink must be ground upon the ink-stone, a slab of slate. Intense blackness can be secured immediately by using only a few drops of water.

Dry the ink stick, and wrap in paper; never leave it soaking. Ink of good quality, and a clean stone are essential.

Tools perfected by ages of practice in line drawing and brush work, afford the best training for hand and eye. Painting with the Japanese brush leads directly to oil painting. If Japanese materials are not to be obtained or are not desired, the exercises can be carried on with pencil, charcoal, water colors, crayons, and even oil paint.

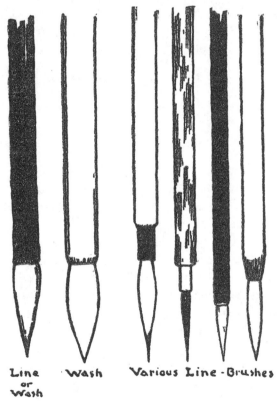

Line or Wash Wash Various Line-Brushes

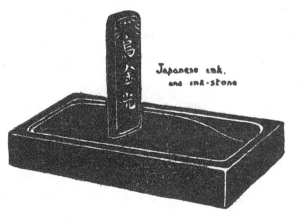

Japanese ink, and ink-stone

Japanese paper for artists' use is made of the bark of the mulberry tree, and is

LINE DRAW-ING II.—JAPA-NESE MATE-RIALS AND BRUSH PRACTICE

For line drawing the brush is held in a perpendicular position, that it may move freely in all directions, much like the etcher's needle. The brush should be well charged with ink, then pressed firmly down upon the paper till it spreads to the width desired for the line.

Draw with the whole hand and arm in one sweep, not with the fingers. Steady the hand if necessary by resting the wrist or end of the little finger on the paper. Draw very slowly. Expressive line is not

Practice-lines drawn with Japanese Brush (reduced ½.)

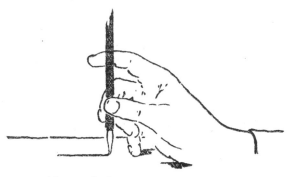

Manner of holding the Brush

made by mere momentum, but by force of will controlling the hand. By drawing slowly the line can be watched and guided as it grows under the brush point. Slight waverings are not objectionable; in fact they often give character to the line.

EXERCISE

Begin with straight lines, remembering that straightness of direction is the essential thing, not mere geometric straightness. After some practice with straight lines, try curves; then irregular lines. Copy brush drawings from Japanese books, for a study of control of the hand and quality of touch, No. 11, p. 19.

This practice work can be done upon ordinary paper. The aim of such an exercise is to put the hand under control of the will, but too much time should not be given to mere practice, apart from design. Quality and power of line are illustrated in the drawings of masters, No. 10 and p. 18. These may be copied later on, for a study of advanced drawing.

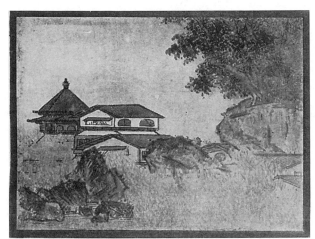

Part of screen by SOGA SHUBUN, Chinese XV cent. Museum of Fine Arts, Boston. A.W.Dow photo

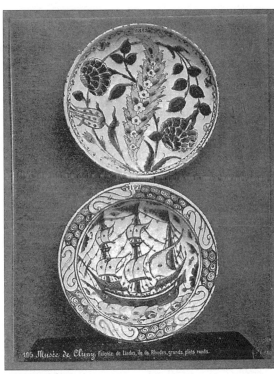

RHODIAN Plates, Cluny Museum, Paris.

No.10

KENZAN. Japanese XVII cent. Lawrence photo
Museum of Fine Arts. Boston.

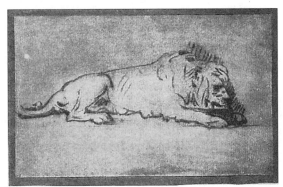

REMBRANDT Pen drawing

17

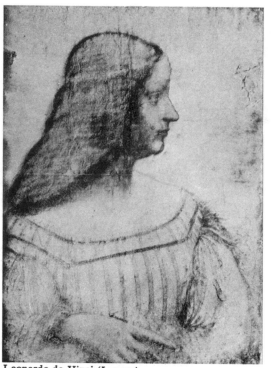

Leonardo da Vinci (Louvre)

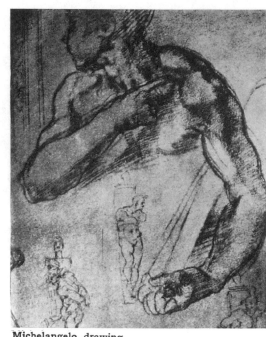

Michelangelo, drawing

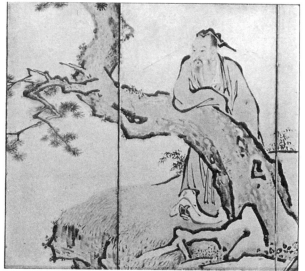

Kano Tanyu, XVII cent. (part of screen, Museum of Fine
Arts, Boston)

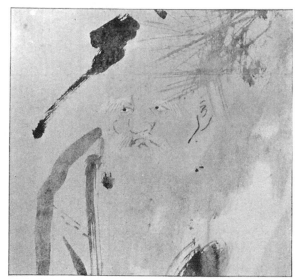

Kano Naonobu, XVII cent. (from screen in ink, Museum
of Fine Arts, Boston)

18

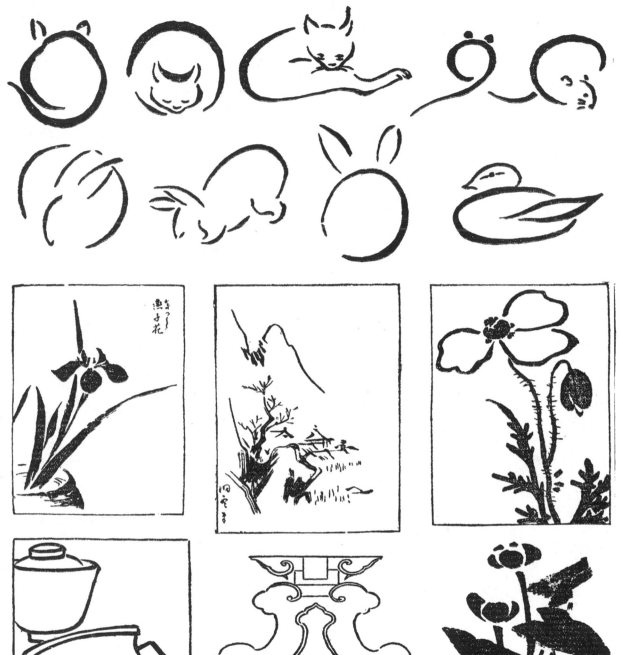

Brush drawings from Japanese Books No. 11

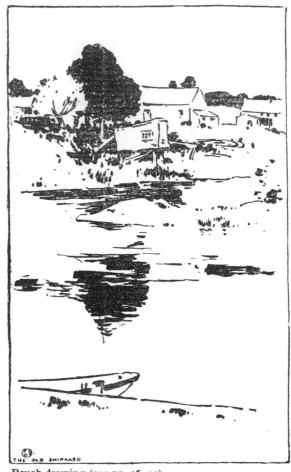

Brush drawing (see pp. 16, 95)

PRINCIPLES OF COMPOSITION

III.—WAYS OF CREATING HARMONY

FINE art, by its very name, implies fine relations. Art study is the attempt to perceive and to create fine relations of line, mass and color. This is done by original effort stimulated by the influence of good examples.

As fine relations (that is, harmony, beauty) can be understood only through the appreciations, the whole fabric of art education should be based upon a training in appreciation. This power cannot be imparted like information. Artistic skill cannot be given by dictation or acquired by reading. It does not come by merely learning to draw, by imitating nature, or by any process of storing the mind with facts.

The power is within — the question is how to reach it and use it.

Increase of power always comes with exercise. If one uses a little of his appreciative faculty in simple ways, proceeding on gradually to the more difficult problems, he is in the line of natural growth. To put together a few straight lines, creating a harmony of movement and spacing, calls for exercise of good judgment and appreciation. Even in this seemingly limited field great things are possible; the proportions of the Parthenon and Giotto's Tower can be reduced to a few straight lines finely related and spaced.

Effective progress in composition depends upon working with an organized and definite series of exercises, building one experience upon another, calling for cultivated judgment to discern and decide upon finer and finer relations. Little can be expressed until lines are arranged in a Space. Spacing is the very groundwork of Design. Ways of arranging and spacing I shall call

PRINCIPLES OF COMPOSITION

In my experience these five have been sufficient:

1. OPPOSITION
2. TRANSITION
3. SUBORDINATION
4. REPETITION
5. SYMMETRY

These names are given to five ways of creating harmony, all being dependent upon a great general principle, PROPORTION or GOOD SPACING.

1. OPPOSITION. Two lines meeting form a simple and severe harmony.

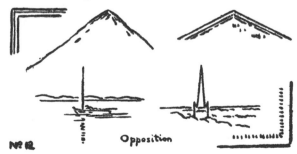

Opposition

Nº 12

Examples will be found in Greek door-ways, Egyptian temples and early Renaissance architecture; in plaid design; also in landscape where vertical lines cut the horizon (see pp. 21, 45, 46.)

This principle is used in the straight line work in squares and rectangles, pp. 32, 33, 39, and in combination with other principles, pp. 25, 29.

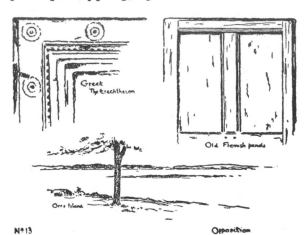

N° 13 Opposition

2. TRANSITION. The arrangement thus designated involves a step beyond Opposition. Two straight lines meeting in opposing directions give an impression of abruptness, severity, or even violence; the difference of movement being emphasized. If a third line is added, as in the sketches below, the opposition is softened and an effect of unity and completeness produced.

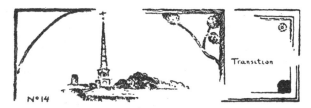

N° 14 Transition

This combination typifies beauty itself which has been defined as consisting of elements of difference harmonized by elements of unity.

A very common example of Transition is the bracket, No. 15. The straight line is modified into curves and may be elaborated with great complexity of modelling.

Instead of a drawn line of transition there may be only a suggestion of one, but the effect is the same; a softening of the corner angle, No. 14 and pp. 58, 60. In pictorial art the vignette, in architecture the capital, are examples of the transition principle. In design an effect of Transition may be produced by radiation. (Illustrations below.)

Accidental transitions occur in nature in the branching of old trees, where the rhythmic lines are thus unified.

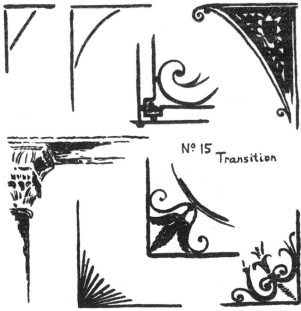

N° 15 Transition

For convenience the suggestions for class work are grouped together in the following

EXERCISE

Opposition. Copy the sketches and illustrations, enlarged. Design straight-line arrangements of mouldings, plaids and rectangular panellings, Nos. 13, 18, 24. Find examples in nature, and draw in line, with brush, pen or pencil without a border.

Transition. Copy the sketches, as before. Draw a bracket in straight line, modifying into curved. Design corner ornaments for panels and book covers; metal work for cabinet. No. 18.
Find examples in nature and draw in line. No. 18.
It is important in all such work to make a number of sketches from which the best may be chosen.

3. SUBORDINATION. Neither of the foregoing principles is often found alone as the basis of a single work. Transition in particular, usually serves to harmonize the parts of a composition. The principle Subordination is a great constructive idea not only in the space arts but in all the fine arts:
To form a complete group the parts are attached or related to a single dominating element which determines the character of the whole.
A tree trunk with its branches is a good type of this kind of harmony; unity secured through the relation of principal and subordinate, even down to the veinings of leaves — a multitude of parts organized into a simple whole.
This way of creating beauty is conspicuous in the perfect spacing and line-rhythm of Salisbury cathedral, St. Maclou of Rouen and the Taj Mahal; in Piero della Francesca's "Resurrection" and Millet's "Goose-girl"; in some Byzantine design and Persian rugs (see pp. 58, 65, 98.)
It governs the distribution of masses in Dark-and-Light composition, and of hues in Color schemes.
It appears in poetry (the Odyssey for example) in the subordination of all parts to the main idea of the subject. It is used constructively in musical composition.
Whenever unity is to be evolved from complexity, confusion reduced to order, power felt — through concentration, organization, leadership — then will be applied the creative principle called here Subordination.

In Line Composition the arrangement by principal and subordinate may be made in three ways, No. 16:
1. By grouping about an axis, as leaf relates to stem, branches to trunk.
2. By radiation, as in flowers, the rosette, vault ribs, the anthemion.
3. By size, as in a group of mountain peaks, a cathedral with its spire and pinnacles, tree clusters, or Oriental rug with centre and border; p. 65.

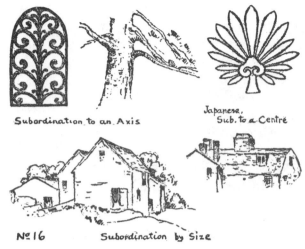

Subordination to an Axis

Japanese,
Sub. to a Centre

Nº 16 Subordination by Size

Art-interest in any of these lies in the fineness of relation. A throwing together of large and small; mere geometric radiation; or conventional branching can never be other than commonplace. A work of fine art constructed upon the principle of Subordination has all its parts related by delicate adjustments and balance of proportions, tone and color. A change in one member changes the whole. No. 22.

To discover the meaning and the possibility of expression in this form of composition the student may work out a series of problems as suggested in this

EXERCISE

The instructor draws flower or fruit with stem and leaves. The pupil arranges this motif in various rectangular spaces (page 25), combining the 1st and 3rd forms of subordination, and using his critical judgment in a way that is of great value to the beginner in composition. The pupil now draws the same or similar subjects from nature, acquainting himself with their form and character; then composes them in decorative or pictorial panels — an art-use of representative drawing as well as exercise in appreciation.

Copy the examples of the 2nd kind of Subordination, and design original rosettes, anthemions, palmettes, thinking chiefly of the spacing and rhythm.

Find examples in nature; chimneys and roofs, boats with masts and sails, or tree groups. Draw and arrange in spaces. Nos. 16, 18, 26, 28, 37, 61.

After choosing the best out of many trial sketches, draw in line with the Japanese brush. Then, for further improvement in arrangement, and refinement of line-quality, trace with brush and ink upon thin Japanese paper.

4. **REPETITION.** This name is given to the opposite of Subordination — the production of beauty by repeating the same lines in rhythmical order. The intervals may be equal, as in pattern, or unequal, as in landscape, see below and No. 20.

Nº 17 Repetition

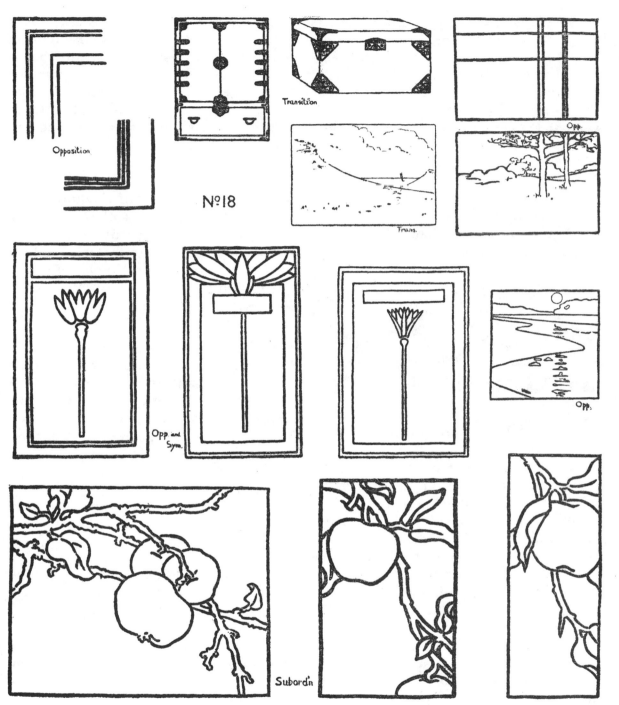

Opposition

Transition

Opp.

N°18

Trans.

Opp. and
Sym.

Opp.

Subordn

25

Of all ways of creating harmony this is the most common, being probably the oldest form of design. It seems almost instinctive, perhaps derived from the rhythms of breathing and walking, or the movement of ripples and rolling waves. Marching is but orderly walking, and the dance, in its primitive form, is a development of marching. Children make rows and patterns of sticks or bits of colored paper, thinking of them as in animated motion. In early forms of art the figures march or dance around the vases, pots and baskets.

Nº 19 Peruvian tapestry

This principle of Repetition is the basis of all music and poetry. The sacred dance of the savage is associated with the drum and other primitive instruments for marking rhythm; with the chant and mystic song. From such rude beginnings, from the tomtoms, trumpets and Pan-pipes of old, music has developed to the masterpieces of modern times through the building of harmony upon harmony,— composition.

From the crude rhythm of the savage, like the Australian song "Eat; eat; eat," from the battle cries and folk poems of barbaric peoples, there has been refinement upon refinement of word-music ever moving towards the supreme. This gave the world the verse of Sappho which Swinburne thought the most beautiful sounds ever produced in language. From the rude patterns marked with sticks on Indian bowls and pots, or painted in earth colors on wigwam and belt, or woven on blanket, this form of space art has grown, through the complexities of Egyptian and Peruvian textile design to the splendor of Byzantine mosaic, the jewel patterns of the Moguls, and Gothic sculpture; from rock-cut pillars of cave temples to the colonnade of the Parthenon. (For examples of primitive design see the works of William H. Holmes.)

Repetition, be it remembered, is only a way of putting lines and spaces together, and does not in itself produce beauty. A mere row of things has no art-value. Railroads, fences, blocks of buildings, and all bad patterns, are, like doggerel rhyme, examples of repetition without art.

Repetition in fine spacing, with the intention of creating a harmony, becomes a builder of art fabric.

EXERCISE

1. Borders. Divide a long space by vertical or oblique lines at regular intervals. By connecting the ends of these with straight lines, develope many series of meanders, frets and zigzags. Waves and scrolls are evolved from these by changing straight to curved line, **No.** 20a, and p. 56.

2. Surface pattern. Subdivide a space (freehand) into squares, diamonds or triangles, determining the size of the unit desired. This will give a general plan for the distribution of figures. In one of these spaces compose a simple group in straight lines, line and dot, or straight and curved, if only geometric pattern be desired; or a floral form for a sprig pattern. In the composition of this unit the principle of Subordination will be remembered.

As soon as the unit is repeated a new set of relations will be created, dependent upon the spacing. A secondary pattern forms itself out of the background spaces. Hence the designer must decide whether the unit is to fill the skeleton square completely, have a wide margin, or over-run the square. Repeating the figure in these various ways will determine the best size. The main effort should be given to producing a fine relation between one unit and its neighbors and between pattern and background. All the best work in Repetition has this refined harmony of spacing. No. 20b below and pp. 13, 65, 66, 85.

Copy the illustrations of Repetition in this book, and make original variations of them. Copy, in line, the units of early Italian textiles, Oriental rugs or any of the best examples to be found in museums or in illustrated art-books. See "Egg and Dart" from the Parthenon, p. 30, also pp. 67, 121.

For anatomy and planning of pattern, see the works of Lewis F. Day.

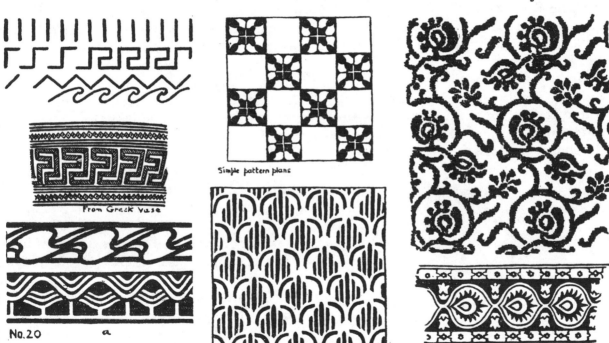

Simple pattern plans

From Greek Vase

No. 20 a

b

Two Tracings from fine old patterns

SYMMETRY. The most common and obvious way of satisfying the desire for order is to place two equal lines or shapes in exact balance, as in a gable, windows each side of a door, or objects on a shelf. The term Symmetry applies to three- and four-part groups, or others where even balance is made, but here it refers mainly to a two-part arrangement.

Sometimes construction produces Symmetry, as in the human body; ships; Greek and Rennaissance architecture; furniture; pottery; books. Partly from this cause and partly through imitation, Symmetry, like Repetition, has come to be used in cheap and mean design where no regard is paid to beauty of form.

Japanese art, when influenced by Zen philosophy, as Okakura Kakuzo tells us in "The Book of Tea", avoids symmetry as uninteresting. In Gothic art, the product of richly inventive and imaginative minds, symmetry was never used in a commonplace way.

This Principle of Composition — when united to fine spacing, — produces, in architecture an effect of repose and completeness; in design a type of severely

beautiful form, as seen in a Greek vase or the treasures of the Sho-so-in at Nara where so much of the older Japanese art has been preserved.

A few examples of Symmetry are given here; the student will readily find others. Exercises can be easily devised, following the steps suggested under other principles. See opposite, and Nos. 42, 43.

PROPORTION or GOOD SPACING. Principles of Composition, I must repeat, are only ways of arranging lines and shapes; art is not produced by them unless they are used in combination with this general principle, — Good Spacing. They are by no means recipes for art, and their names are of little consequence. Appreciation of fineness of relations must always govern the method and form of composition. It is possible to use all the principles here discussed, and to complete all the exercises, without gaining much, if any, art experience. The main thing is the striving for the best, the most harmonious, result that can be obtained. One way to accomplish this is to compare and choose continually — making many designs under one subject and selecting the best.

The great general principle of Proportion needs no special illustration or exercise, because it is so intimate a part of all other principles and exercises. It may be studied in every example of supreme art. It is the foundation of all the finest work in line and mass. The mystery of Spacing will be revealed to the mind that has developed Appreciation.

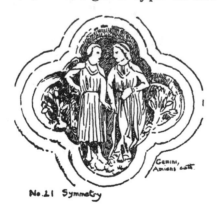

No. 21 Symmetry

Gothic. CHARTRES Cathedral XIIcent. From Musée de Sculpture Comparée, Paris

PINTORICCHIO School of (Symmetry) Anderson photo

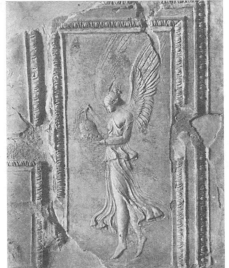

ROMAN, Stucco (Sub. and Rep.) Anderson, photo.

Chinese pewter, M.F.A. Boston (Ceb and Sub.) 3 Coolidge photo.

No. 22

MAUVE. Water Color (Repetition) Mansell, photo.

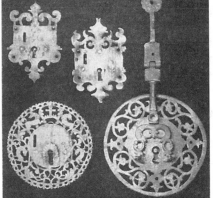

Iron Escutcheons M.F.A. Boston (Rch.& Sub.)³ Coolidge photo.

29

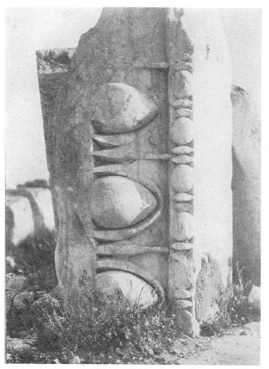

Egg-and-Dart. The PARTHENON. A.W. Dow, photo.

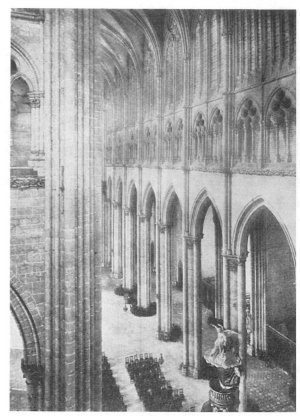

Amiens Cathedral.

No. 23

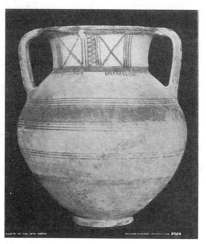

Greek vase. Museum of Fine Arts, Boston.

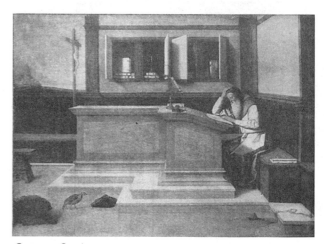

Catena, St. Jerome. National Gallery, London.

30

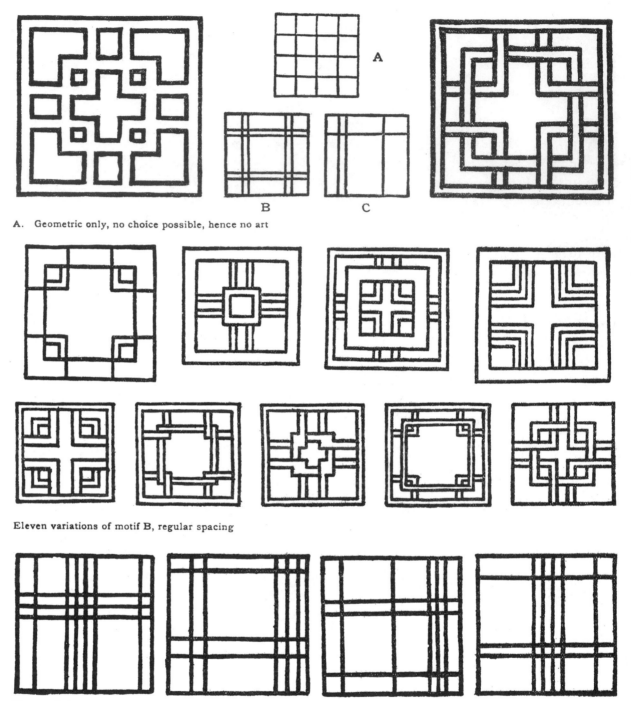

A. Geometric only, no choice possible, hence no art

Eleven variations of motif B, regular spacing

Four variations of motif C, irregular spacing

32

LINE

IV.—COMPOSITION IN SQUARES AND CIRCLES

AFTER working with the principles long enough to understand their nature, and to see what can be done with them, the student is ready for problems in composition. Practice in line arrangement is a preparation for all kinds of art work, be it design, painting, sculpture or architecture.

Choose an enclosed area of definite and regular shape, and break it up into a harmonious group of smaller areas by drawing lines. For these elementary exercises in composition the square and circle are best because their boundaries are unchangeable, and attention must be fixed upon interior lines. Take first the square, using straight lines of equal thickness drawn with the brush as suggested in chapter II. The result should be a harmony of well-cut space, a little musical theme in straight lines and grouped areas. Make many trial arrangements, sketching lightly with charcoal on "bogus" or lining paper. Select the best, correct them, and draw with brush and ink over the charcoal lines. From these choose the most satisfactory, place thin Japanese paper over them and trace in firm black lines, freehand, with the Japanese brush. Avoid hard wiry lines and all that savors of rule and compass or laborious pains-taking. Use no measure

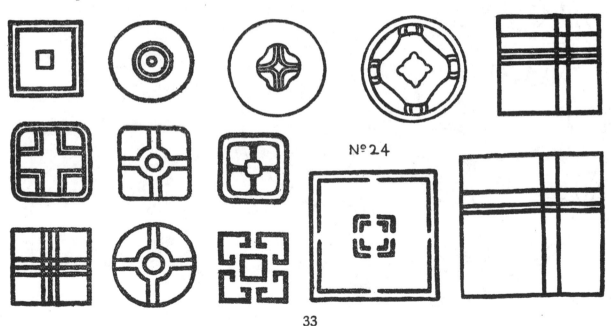

Nº 24

33

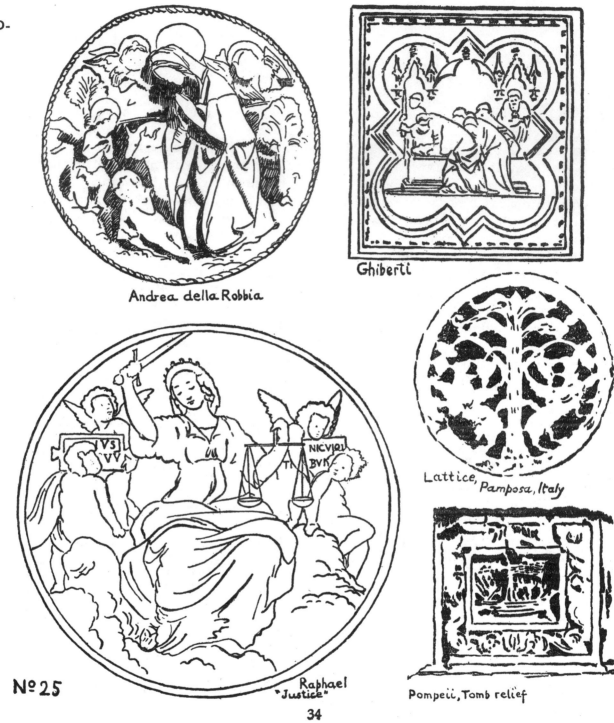

LINE
IV.—COMPO-
SITION IN
SQUARES
AND
CIRCLES

Andrea della Robbia

Ghiberti

Lattice, Pamposa, Italy

Nº 25

Raphael
"Justice"

Pompeii, Tomb relief

of any kind; sizes, shapes and directions must be decided upon without mechanical aids.

Never try to erase an ink line, — if a mistake occurs begin again.

Tracing, for the art-purpose of improving proportions and acquiring an expressive brush-touch, is a most valuable help to the production of good work. Architects use tracing-paper for changes in plans. Japanese artists trace again and again until satisfied with the quality of touch and strength of drawing.

Straight line is chosen for elementary practice because of its simplicity, and because it prepares for work with curves. The finest curve is measured by a series of straight lines in harmonic relations of rhythm and proportion (p. 42). After some experience with straight line, cut areas with curved,— geometric, flower, fruit, landscape or figure.

Equal thickness of line is advisable now, to fix attention upon direction, touch and spacing. Variation in width will come later in notan of line (page 54) and in representative drawing (page 51) where texture and modelling are to be indicated.

The main purpose of this and all exercises in this book is the creation of harmony, hence if the result has but a slight degree of line-beauty it can be considered a first step in Art.

The examples are chosen from students' work, from Japanese books, from design, craft and architecture. They illustrate various ways of treating squares and circles according to principles of composition.

1. Copy these enlarged, with brush.
2. Select one, as a theme, and make many variations.
3. Originate new line-schemes in squares and circles.

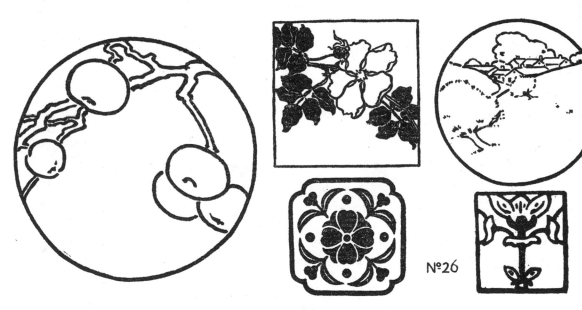

No 26

LINE
IV.—COMPO-
SITION IN
SQUARES
AND
CIRCLES

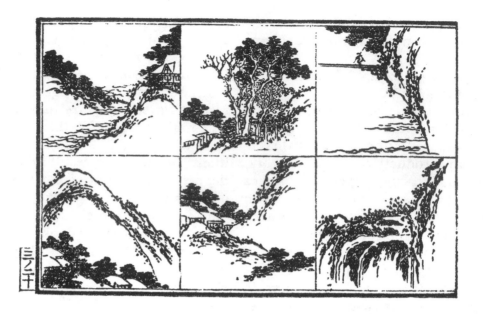

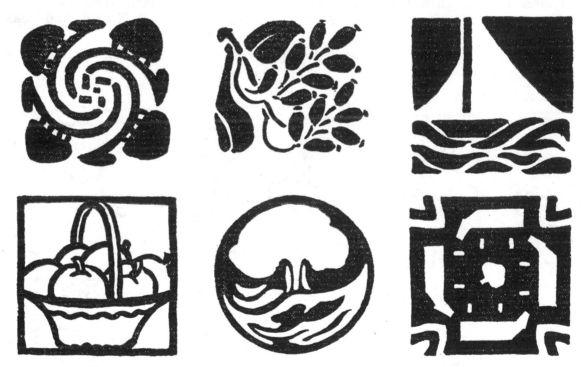

Nº 27 Units for wood-block printing, stencilling and hand-coloring

APPLICATIONS

1. Ginghams, plaids, embroidery, stencil.

2. Panelling, window sashes, leading for glass, inlaid wood, mosaic, enamel on metal.

3. Incised lines in wood, clay or metal, low relief modelling.

Study of the principle precedes application in all cases. It is true that the limitations of material must be recognized in making designs for special purposes. The substance or surface for which the design is intended will itself suggest the handling; but material teaches us nothing about the finer relationships. First study the art of design; develop capacity by exercise of the inventive and appreciative faculties; then consider the applications in craft or profession.

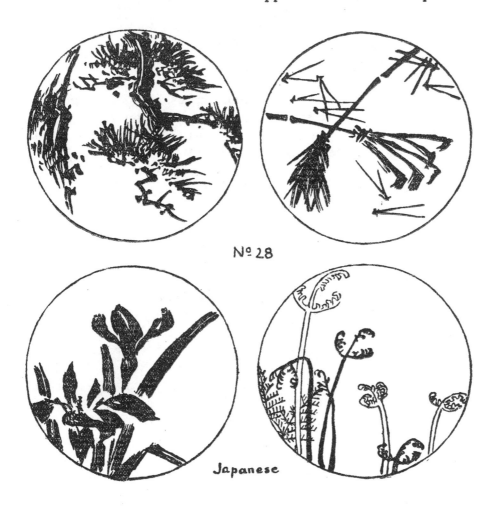

Nº 28

Japanese

LINE

V. — COMPOSITION IN RECTANGLES — VARIATION

IN the search for finer relations there must be every opportunity for choice; the better the choice, the finer the art. The square and circle allow choice only as to interior divisions, but the rectangle is capable of infinite variation in its boundary lines.

The scientific mind has sought, by analysis of many masterpieces, to discover a set of perfect proportions, and to reduce them to mathematical form, for example, 3 : 5, or 4 : 7.

The secret of spacing in Greek art has been looked for in the "golden mean", viz : height is to length as length is to the sum of height and length. Doubtless such formulæ were useful for ordinary work, but the finest things were certainly the product of feeling and trained judgment, not of mathematics. Art resists everything that interferes with free choice and personal decision; art knows no limits.

Poverty of ideas is no characteristic of the artist; his mind is ever striving to express itself in new ways.

The personal choice of proportions, tones and colors stamps the work with individuality. A master in art is always intensely individual, and what he does is an expression of his own peculiar choices.

The beauty of proportion in your rectangle is measured by your feeling for fine relations, not by any formula whatever. No work has art-value unless it reflects the personality of its author. What everybody can do easily, or by rule, cannot be art.

The study of Variation tends to lead the mind away from the conventional and humdrum, toward original and individual expression. Variation has no place in academic courses of art teaching, but in composition it is a most important element.

The masters of music have shown the infinite possibilities of variation — the same theme appearing again and again with new beauty, different quality and complex accompaniment. Even so can lines, masses and colors be wrought into musical harmonies and endlessly varied. The Japanese color print exemplifies this, each copy of the same subject being varied in shade or hue or disposition of masses to suit the restless inventive energy of its author. In old Italian textiles the same pattern appears repeatedly, but varied in size, proportion, dark-and-light and color. In times when art is decadent, the designers and painters lack inventive power and merely imitate nature or the creations of others. Then comes Realism, conventionality, and the death of art.

Some experience in choice of proportions and the cutting of rectangular spaces may be gained from the following

<div align="center">EXERCISE</div>

1. Design some simple theme in vertical and horizontal lines and arrange it in several rectangles of the same size, varying the spacing in each, No. 29a.
2. Compose a straight-line theme in several rectangles of different proportions, No. 29b.
3. Choose the best and trace with brush and ink.

In the first case there is variation of interior lines only; in the second all lines are changed. This exercise admits of great expansion, according to age of pupils and limits of time.

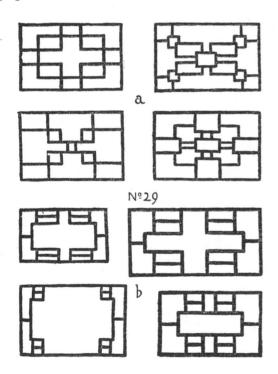

<div align="center">Nº29</div>

EXAMPLES OF RECTANGULAR DESIGN.

Contact with the best works of art is an essential part of art education, for from them comes power and the stimulus to create. The student hears and reads much that passes for art criticism but is only talk about the subject of a picture, the derivation and meaning of a design, or the accuracy of a drawing. These minor points have their place in discussing the literary and scientific sides of a masterpiece; they relate to art only superficially, and give no key to the perception of fine quality.

The most important fact about a great creative work is that it is beautiful; and the best way to see this is to study the art-structure of it,—the way it is built up as Line, Notan, Color,—the principle of composition which it exemplifies. See what a master has done with the very problem you are trying to work out.

This method of approach will involve a new classification of the world's art, cutting across the historical, topical and geographical lines of development. The instructor in composition will illustrate each step with many examples differing as to time, locality, material and subject, but alike in art-structure.

Museum collections might be used for a series of progressive studies based upon composition; taking up one principle at a time and seeking illustrations in a group of wide range,—a picture, sculpture, architecture, Gothic carving, metal work, old textile, bit of pottery, Japanese print.

<div align="center">39</div>

The beauty of simple spacing is found in things great and small, from a cathedral tower to a cupboard shelf.

The campanile of the Duomo of Florence (No. 30) designed by that master of architecture and painting, Giotto, is a rectangular composition of exceeding beauty. Its charm lies chiefly in its delicately harmonized proportions on a straight - line scheme. It is visual music in terms of line and space. The areas are largest at the top, growing gradually smaller in each of the stories downward. The graceful mouldings, the window tracery, the many colors of marble and porphyry are but enrichments of the splendid main lines.

Nº 30
Giotto's Tower
(traced from a
photograph)

The Ca' d'Oro of Venice (No. 31, A) presents this rectangular beauty in an entirely different way. First, a vertical line divides the façade into two unequal but balanced proportions; each of these is again divided by horizontal lines and by windows and balconies into smaller spaces, the whole making a perfect harmony—each part related to, and affected by every other part.

The tokonoma of a Japanese room (No. 31, B) is arranged in a similar rectangular scheme. A vertical line, as in the Venetian palace façade, divides the whole space into two; one of these is divided again into recesses with shelves or sliding doors; the other is for pictures (kakemono), not more than three of which are hung at a time. No. 31, C shows three of these sets of shelves. The Japanese publish books with hundreds of designs for this little recess. The fertility of invention combined with feeling for good spacing, even in such a simple bit of craft, is characteristic of the Japanese. Their design books, from which I have copied many examples for this volume, are very useful to the student of art.

Style, in furniture, is a matter of good spacing, rather than of period or person. The best designs are very simple, — finely balanced compositions of a few straight lines (No. 31, D).

Book covers with their lettering and decorations, and book pages with or without illustrations are examples of space cutting, — good or commonplace according to the designer's feeling for line-beauty. In the early days of printing the two pages of an open book were considered together as a single rectangular space. Into this the type was to be set with the utmost care as to proportion and margin.

EXERCISE

The few examples given here show how varied are the applications of a single principle. The study of these will suggest a field for research. If possible the student should work from the objects themselves or from large photographs; and from the original Japanese design books. These

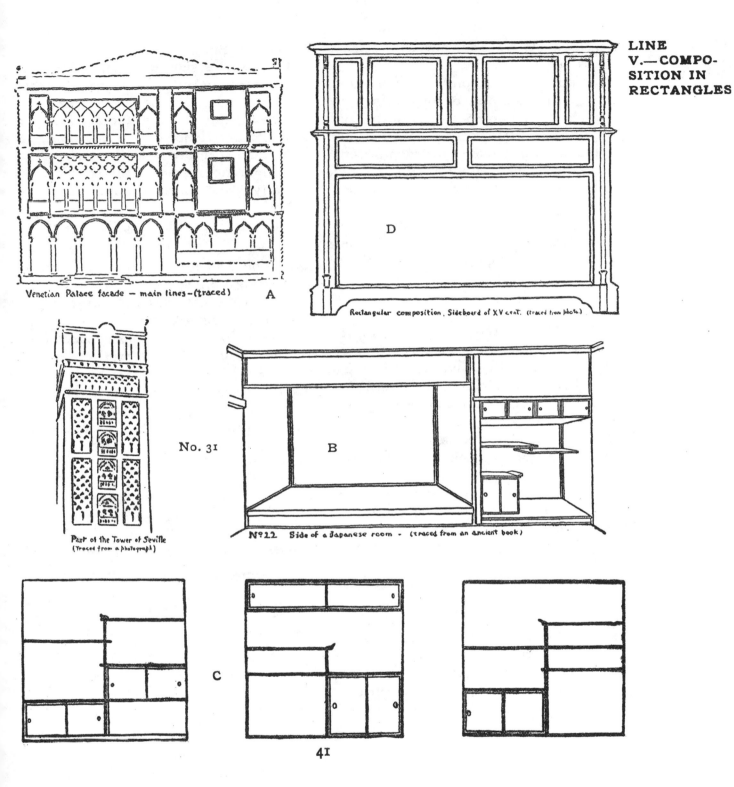

Venetian Palace facade — main lines — (traced) A

Rectangular composition. Sideboard of XV cent. (traced from photo.)

D

No. 31

Part of the Tower of Seville
(Traced from a photograph)

B

Nº 22 Side of a Japanese room — (traced from an ancient book)

C

41

tracings are given for purposes of comparison.

1. Copy the examples, without measuring. An attempt to copy brings the pupil's mind into contact with that of a superior, and lets him see how difficult it is to reach the master's perfection. Copying as a means of improving one's style is the opposite of copying as a substitute for original work.

2. After making the best possible copies, invent original variations of these themes,— keeping the same general plan but changing the sizes.

COMPOSITION OF POTTERY FORMS. Makers of modern commercial ware usually leave beauty of line out of account, thinking only of utility,— of the piece of pottery as a feeding-dish, or as a costly and showy object. The glaring white glaze, harsh colors and clumsy shapes of common table-ware must be endured until there is sufficient public appreciation to demand something better; yet even this is less offensive than the kind that pretends to be art,— bad in line and glittering with false decoration.

Pottery, like other craft-products, is truly useful when it represents the best workmanship, combined with feeling for shape, tone, texture and color,— in a word, fine art.

Such quality is found, to mention only a few cases, in some of the "peasant wares"; in the best Japanese pottery, ancient and modern; in Chinese, especially of the Sung period (A. D. 960-1280); in Moorish, Persian, Rhodian and Greek. When each maker tried to improve upon older models, and had the taste and inventive genius to do it, the art grew to supreme excellence; even fragments of such handicraft are now precious.

The difference between the contours of a really great piece of pottery and an ordinary one may seem very slight, but in just this little difference lies the art.

EXERCISE

One good way to stimulate invention in composing pottery shapes is to evolve them from rectangles. In the straight line there is strength; a curve is measured by a series of straight lines connected in rhythm. No. 32a. This principle is recognized in blocking out a freehand drawing,— a process often misunderstood and exaggerated.

Curved profiles are only variations of rectangular forms, for example the bowl in No. 32 b.

Change the height and a series of new shapes will result. As the top and bottom lines remain the same we have to compare the curved sides only.

Another effect (c) comes from varying

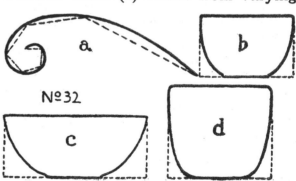

Nº 32

the width; and still another (d) by changing both height and width.

In No. 33 are students' drawings of pottery profiles evolved from rectangles.

For brushwork, in this exercise, it is well to indicate the lines of the rectangle in pale red, the pottery in black. Make many sketches, select the best profiles, improve them by tracing in ink, and compare with historic pieces.

Drawing from the finest examples of pottery, and making original variations of the forms, will aid in drawing from the cast or the nude, because of the intimate study of the character of curves.

FLOWERS and other forms as LINE-MOTIVES. The rectangular space may be subdivided, as was the square, by a simple line-motif,—flower, fruit, still life, animal or figure,—following some Principle of Composition. In chapter III, under Subordination, an exercise was suggested and illustrated; it could be taken up again at this point, with new subjects, for a study of Variation. As rectangular compositions will be found under Notan and Color, it is not necessary to consider them further here as pure line, except in the case of Landscape, to which a special chapter is given.

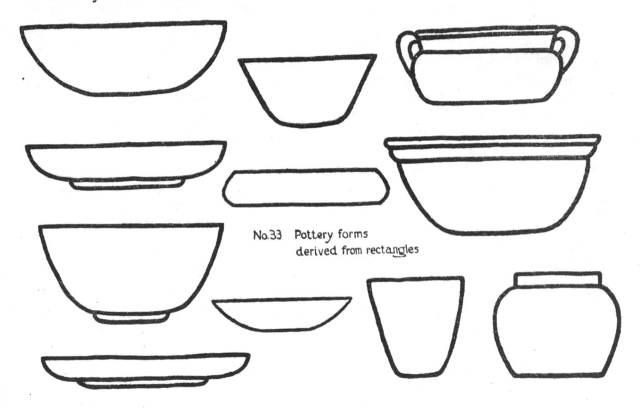

No. 33 Pottery forms
derived from rectangles

LINE

VI.—LANDSCAPE COMPOSITION

THE modern arbitrary division of Painting into Representative and Decorative has put composition into the background and brought forward nature-imitation as a substitute. The picture-painter is led to think of likeness to nature as to the most desirable quality for his work, and the designer talks of "conventionalizing"; both judging their art by a standard of Realism rather than of Beauty.

In the world's art epochs there was no such division. Every work of space-art was regarded as primarily an arrangement, with Beauty as its raison d'être. Even a portrait was first of all a composition, with the facts and the truth subordinate to the greater idea of æsthetic structure. Training in the fundamental principles of Composition gave the artists a wide field — they were at once architects, sculptors, decorators and picture-painters.

Following this thought of the oneness of art, we find that the picture, the plan, and the pattern are alike in the sense that each is a group of synthetically related spaces. Abstract design is, as it were, the primer of painting, in which principles of Composition appear in a clear and definite form. In the picture they are not so obvious, being found in complex interrelations and concealed under detail.

The designer and picture-painter start in the same way. Each has before him a blank space on which he sketches out the main lines of his composition. This may be called his Line-idea, and on it hinges the excellence of the whole, for no delicacy of tone, or harmony of color can remedy a bad proportion. A picture, then, may be said to be in its beginning actually a pattern of lines. Could the art student have this fact in view at the outset, it would save him much time and anxiety. Nature will not teach him composition. The sphinx is not more silent than she on this point. He must learn the secret as Giotto and della Francesca and Kanawoka and Turner learned it, by the study of art itself in the works of the masters, and by continual creative effort. If students could have a thorough training in the elements of their profession they would not fall into the error of supposing that such a universal idea as Beauty of Line could be compressed into a few cases like the "triangle," "bird's-wing," "line of beauty," or "scroll ornament," nor would they take these notions as a kind of receipt for composing the lines of pictures.

Insistence upon the placing of Composition above Representation must not be considered as any undervaluation of the latter. The art student must learn to

44

represent nature's forms, colors and effects; must know the properties of pigments and how to handle brushes and materials. He may have to study the sciences of perspective and anatomy. More or less of this knowledge and skill will be required in his career, but they are only helps to art, not substitutes for it, and I believe that if he begins with Composition, that is, with a study of art itself, he will acquire these naturally, as he feels the need of them.

Returning now to the thought that the picture and the abstract design are much alike in structure, let us see how some of the simple spacings may be illustrated by landscape.

Looking out from a grove we notice that the trees, vertical straight lines, cut horizontal lines,—an arrangement in Opposition and Repetition making a pattern in rectangular spaces. Compare the gingham and landscape on page 22. This is a common effect in nature, to be translated into terms of art as suggested in the following exercise.

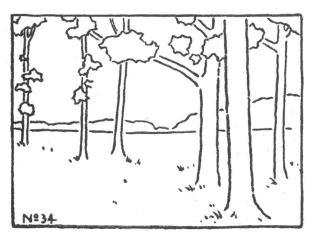

No. 34 is a landscape reduced to its main lines, all detail being omitted.

Make an enlarged copy of this, or design a similar one. Then, in the attempt to find the best proportion and the best way of setting the subject upon canvas or paper, arrange this in rectangles of varying shape, some nearly square, others tall, others long and narrow horizontally as in No. 35. To bring the whole landscape into all these will not, of course, be possible, but in each the essential lines must be retained.

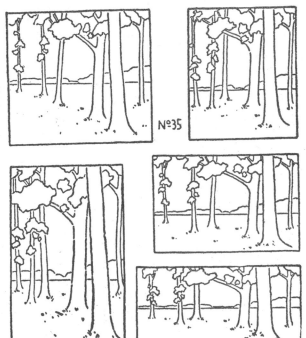

Draw in ink after preliminary studies with pencil or charcoal, correcting errors by tracing.

Then find in nature other similar subjects; sketch and vary in the same way.

Hiroshige (traced from a colored print)

The Annunciation, Piero della Francesca. (tracing)

No. 36

Sketch of part of middle distance – "L'Hiver" by Puvis de Chavannes

Sketch from a picture by Whistler

46

The art of landscape painting is a special subject, not to be treated at length here, but I believe that the true way to approach it is through these or similar exercises.

First study the art, then apply it, whether to landscape or any other kind of expression.

PICTURES COMPOSED ON RECTANGULAR LINES.

Great architects and designers were not the only ones to use this simple line-idea; the masters of pictorial art have based upon it some of their best work; (opposite page).

These tracings from a variety of compositions, old and new (No. 36), show that this combination was chosen either to express certain qualities and emotions, —majesty, solemnity, peace, repose, (Puvis de Chavannes)—or because such a space division was suited to tone-effects (Whistler's Battersea Bridge), or to color schemes (Hiroshige). These should be copied exactly in pencil, then drawn enlarged. Find other examples in museums, illustrated books, or photographs, and draw in the same way.

The student must, however, be warned against mistaking a mere geometric combination of lines for an æsthetic combination. There is no special virtue in a rectangular scheme or any other in itself; it is the treatment of it that makes it art or not art. Many a commonplace architect has designed a tower similar to Giotto's, and many a dauber of oil paint

has constructed a wood interior on a line-plan resembling that of Puvis. So the mere doing of the work recommended here will be of little value if the only thought is to get over the ground, or if the mind is intent upon names rather than principles. The doing of it well, with an artistic purpose in mind, is the true way to develop the creative faculties.

LANDSCAPE ARRANGEMENT,—VARIATION.

Leaving now the rectangular scheme, take any landscape that has good elements, reduce it to a few main lines and strive to present it in the most beautiful way—for example one from No. 61, or one drawn by the instructor, or even a tracing from a photograph. Remember that the aim is not to represent a place, nor to get good drawing now; put those thoughts out of the mind and try only to cut a space finely by landscape shapes; the various lines in your subject combine to enclose spaces, and the art in your composition will lie in placing these spaces in good relations to each other. Here must come in the personal influence of the instructor, which is, after all, the very core of all art teaching. He can bring the pupils up to the height of his own appreciation, and perhaps no farther. The best of systems is valueless without this personal artistic guidance.

At this stage of landscape composition, the idea of Grouping (Subordination) can

be brought in, as a help in arranging sizes and shapes. There is a certain beauty in a contrast of large and small. It is the opposite of Monotony. For instance, compare a street where there is variety in the sizes of buildings and trees, with another of rows of dull ugly blocks. Ranges of hills, spires and pinnacles, clumps of large and small trees, clusters of haystacks, illustrate this idea in landscape.

EXERCISE

To discover the best arrangement, and to get the utmost experience in line and space composition, the landscape should be set into several boundaries of differing proportions, as in Chapter V, and as shown in the examples, keeping the essential lines of the subject, but varying them to fit the boundary. For instance, a tree may be made taller in a high vertical space than in a low horizontal space, (No. 37 below).

After working out this exercise the pupil may draw a landscape from nature and treat it in the same way. Let him rigorously exclude detail, drawing only the outlines of objects.

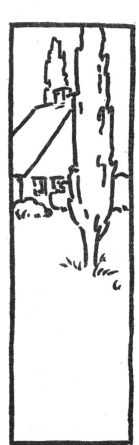
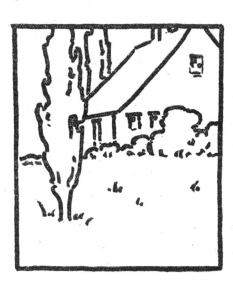
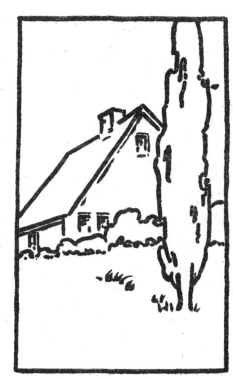

No. 37 A Landscape in three
proportions

LINE

VII.—COMPOSITION IN REPRESENTATION

IN academic art teaching representation is the starting-point. This means that one must first of all "learn to draw", as power in art is thought to be based upon ability to represent accurately and truthfully either nature's facts or historic ornament. I use the word "academic" to define all teaching founded upon representation. The theory may be summed up in two points:

1. Store the mind with facts, to be used in creative work later on.

2. Technique is best acquired by the practice of object and figure drawing.

The first is a purely scientific process, a gathering up of data, with no thought of harmony or originality; hence drawing with such an end in view is not strictly art-work. Nor does the artist need to lumber up his mind; nature is his storehouse of facts. The second point has more reason, but when the aim is for mere accuracy, only a limited amount of skill is acquired and that often hardly more than nice workmanship — not art-skill. The powerful drawing of the masters is largely derived from other masters, not from copying nature. It is an interpretation with the purpose of attaining a high standard. Such drawing aims to express character and quality in an individual way—a thing quite different from fact-statement.

Nature-drawing, wrongly placed and misunderstood, has become a fetich in our modern teaching. Our art critics talk of "just" rendering, "true" values, "conscientious" painting and the like; terms that belong to morals, not art, and could not be applied to Architecture, Music or Poetry. These stock-phrases are a part of that tradition of the elders—that eighteenth century academism still lingering. Representation has but a small place in the art of the world. This is roughly shown in the two lists below:

NON-REPRESENTATIVE

Architecture — Furniture.
Wood carving.
Pottery.
Modelling,— mouldings and pattern.
Metal work.
Inlay,— mosaic, etc.
Geometric design, including
Egyptian, Peruvian and Savage.
Ginghams, plaids and much textile pattern.
Mohammedan art (one great division)
etc.

REPRESENTATIVE

Painting and Sculpture of
Figures, Portraits, Animals,
Flowers, Still Life,
Landscape Painting.

The nature-imitators hold that accurate representation is a virtue of highest order and to be attained in the beginning. It is undeniably serviceable, but to start with it is to begin at the wrong end. It is not the province of the landscape painter, for example, to represent so much topography, but to express an emotion; and this he must do by art. His art will be manifest in his composition; in his placing of his trees, hills and houses in synthetic relations to each other and to the space-boundary. Here is the strength of George Inness; to this he gave his chief effort. He omits detail, and rarely does more than indicate forms.

This relation among the parts of a composition is what we call Beauty, and it begins to exist with the first few lines drawn. Even the student may express a little of it as he feels it, and the attempt to embody it in lines on paper will surely lead to a desire to know more fully the character and shapes of things, to seek a knowledge of drawing with enthusiasm and pleasure.

These things are said, not against nature-drawing — I should advise more rather than less — but against putting it in the wrong place.

The main difference between Academic and Structural (Analytic and Synthetic) is not in the things done, but in the reason for doing them, and the time for them. All processes are good in their proper places.

The relation of representative drawing to a synthetic scheme is this: One uses the facts of nature to express an idea or emotion. The figures, animals, flowers or objects are chosen for the sake of presenting some great historical or religious thought as in della Francesca's Annunciation (No. 36), for decoration of an architectural space (Reims capital, No. 38), because the landscape has special beauty as in Hiroshige's print (No. 8), or because the objects have form and color suggesting a high order of harmony, as in Chinese and Japanese paintings of flowers, or Leonardo's drawings of insects and reptiles.

Another reason for drawing is found in the use of the shapes or hues in design. Desire to express an idea awakens interest in the means. Observation is keen, close application is an easy task, every sense is alert to accomplish the undertaking. This is quite different from drawing anything and everything for practice only.

Mere accuracy has no art-value whatever. Some of the most pathetic things in the world are the pictures or statues whose only virtue is accuracy. The bare truth may be a deadly commonplace.

Pupils should look for character; that includes all truth and all beauty. It leads one to seek for the best handling and to value power in expression above success in drawing.

Composition is the greatest aid to representation because it cultivates judgment as to relations of space and mass. Composition does not invite departure from nature's truth, or encourage inaccuracies of any kind — it helps one to draw in a finer way.

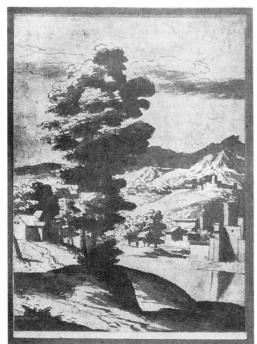

GIORGIONE Venetian School, Notan plan Braun photo

No. 38

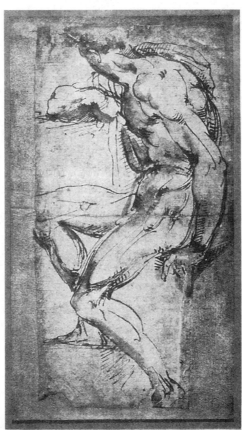

MICHELANGELO Pen and Brush drawing. Rhythm of Line British Museum

KANO GYOKURAKU Japanese XVI cent Lawrence photo M FA Boston
Rhythm of Line

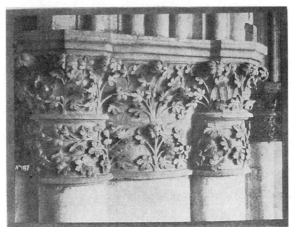

REIMS Cathedral capital Representation composed into a spurn Neurdein photo

51

NOTAN
VIII.
DARK-AND-
LIGHT HAR-
MONIES
FROM THE
MASTERS

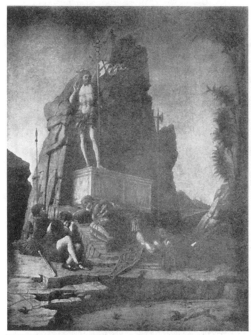

MANTEGNA, National Gallery, London

Japanese. M FA Boston

No.39

South Kensington Museum, London

Sarah Whitman, Gloucester Harbor F A Boston

Gothic, NEVERS Cathedral, X cent. Musée de Sculpture Comparée Paris

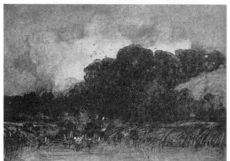

Cotman, Postwick Grove Autotype Co photo

Baptistery, Florence, part of pavement. Alinari photo.

52

NOTAN

VIII.— HARMONY-BUILDING WITH DARK-AND-LIGHT

AS there is no one word in English to express the idea contained in the phrase "dark-and-light," I have adopted the Japanese word "no-tan" (dark, light). It seems fitting that we should borrow this art-term from a people who have revealed to us so much of this kind of beauty. "Chiaroscuro" has a similar but more limited meaning. Still narrower are the ordinary studio terms "light-and-shade," "shading," "spotting," "effect" that convey little idea of special harmony-building, but refer usually to representation.

Notan, while including all that these words connote, has a fuller meaning as a name for a great universal manifestation of beauty.

Darks and lights in harmonic relations —this is Notan the second structural element of space-art; p. 7.

The Orientals rarely represent shadows; they seem to regard them as of slight interest — mere fleeting effects or accidents. They prefer to model by line rather than by shading. They recognize Notan as a vital and distinct element of the art of painting.

The Buddhist priest-painters of the Zen sect discarded color, and for ages painted in ink, so mastering tone-relations as to attract the admiration and profoundly influence the art of the western world.

Our etching and book illustration have long felt the effect of contact with Japanese classic painting, though the influence came indirectly through the Ukiyoye color prints and books.

Such names as Kakei, Chinese of the Sung dynasty (p. 96), Soga Shubun, the Chinese who founded a school in Japan in the fifteenth century (p. 17), Sesshu, one of the greatest painters of all time (p. 97), Sotan, Soami, Motonobu, Tanyu are now placed with Titian, Giorgione (p. 51), Rembrandt, Turner, Corot and Whistler. The works of Oriental masters who felt the power and mystery of Notan are becoming known through the reproductions that the Japanese are publishing, and through precious examples in our own museums and collections. This in one of the forces tending to uproot our traditional scientific art teaching which does not recognize Dark-and-Light as worthy of special attention.

Appreciation of Notan and power to create with it can be gained, as in the case of Line, by definite study through progressive exercises. At the outset a fundamental fact must be understood, that synthetically related masses of dark and light convey an impression of beauty entirely independent of meaning,— for example, geometric patterns or blotty ink sketches by Dutch and Japanese.

When this occurs accidentally in nature,— say a grove of dark trees on a light hillside, or a pile of buildings against the morning sky,— we at once feel the charm and call the effect "picturesque." The quality which makes the natural scene a good subject for a picture is like musical harmony. It is the "visual music" that the Japanese so love in the rough ink paintings of their masters where there is but a hint of facts (pp. 97, 99)— a classic style which is the outward expression of a fine appreciation, and whose origin and practice are admirably set forth in " The Book of Tea." Recognition of Notan as an individual element will simplify the difficulties of tone-composition and open the way for growth in power

NOTAN OF LINE. As long as the lines of a design are kept of uniform width, the beauty is limited to proportion of areas and quality of touch, but widen some of the lines, and at once appears a new grace, Dark-and-Light. The textile designers who are restricted to straight lines, have recourse to this principle. They widen lines, vary their depth of tone, glorify them with color, and show that what seems a narrow field is really one of wide range.

EXERCISE

Choose some of the previous geometric line patterns, and widen certain of the lines, as illustrated in the plate. Incidentally this will give good brush practice, as the lines are to be drawn at one stroke. Push the point of the brush down to the required width, then draw the line. **Try** a large number of arrangements, set them up in a row and pick out the best. In choosing and criticising, remember that every part of a work of art has something to say. If one part is made so prominent that the others have no reason for being there, the art is gone. So in this case; if one line asserts itself to the detriment of the others, there is discord. There may be many or few lines, but each must have its part in the whole. In a word, wholeness is essential to beauty; it distinguishes Music from Noise.

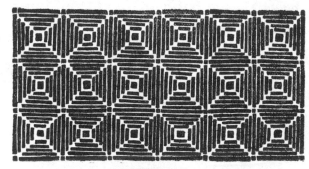

N° 40 Notan of Line

LETTERING. When forming part of an artistic composition, in books, posters, manuscripts, illuminations, etc., lettering should be classed as Notan of Line. Obviously the spacing of masses of letters has first consideration, and is usually a simple problem in rectangular composition. The effect is a tone or group of tones more or less complicated according to sizes of letters, thickness of their lines and width of spaces between and around them. I have found the reed-pen and the Japanese brush (clipped) the best implements for students' lettering (see below). Having suggested that Lettering, including Printing, as an art, is a problem in composition of line and notan, it seems hardly worth while to introduce special exercises here. Johnston has treated this subject exhaustively; the reader is referred to his book " Writing, Illuminating and Lettering," to Walter Crane's and other good books on lettering. Compare fine printing, old and new, Japanese, Chinese and Arabic writing, and ancient manuscripts and inscriptions — Egyptian, Greek, and Mediæval.

Japanese brushes clipped for lettering No 41

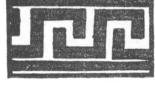

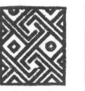
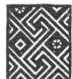
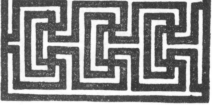

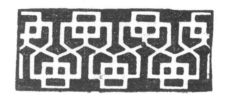

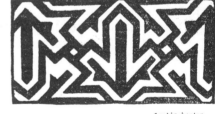

Arabic border

Repetition, p. 24, and variation in two values, p. 67

Landscape compositions by **HOKUSAI**, three values, pp. 76, 82, 114

57

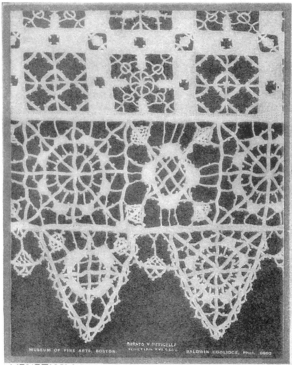

VENETIAN Lace

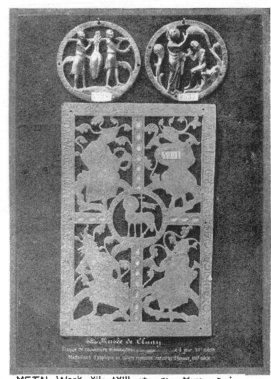

METAL Work XII and XIII cent Cluny Museum, Paris

No. 42

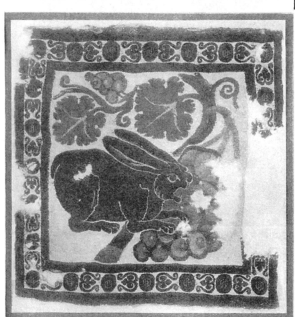

COPTIC TEXTILE MFA Boston

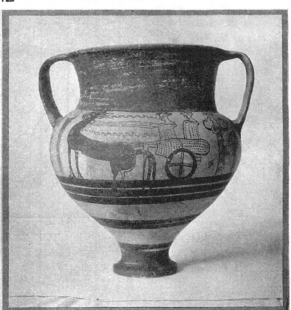

GREEK VASE Metropolitan Museum, New York

58

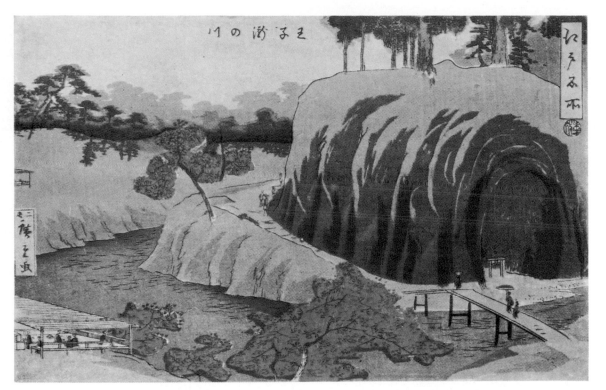

No. 8. HIROSHIGE "Taki no gawa at Oji"

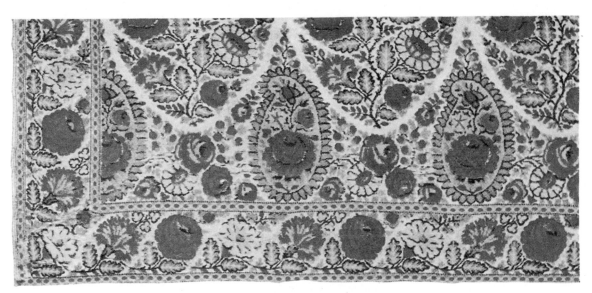

No. 9. Persian woolen, ancient

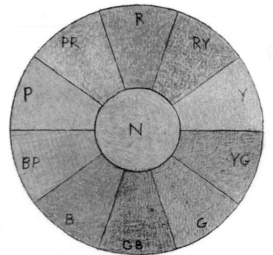

COLOR XIV.

COLOR THEORY
HUE
No. 63

SCALE of 10 HUES and NEUTRAL. Middle Value

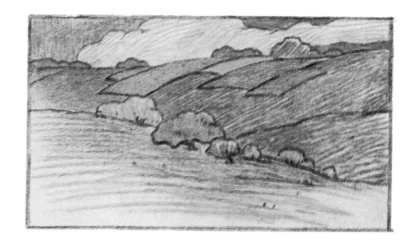

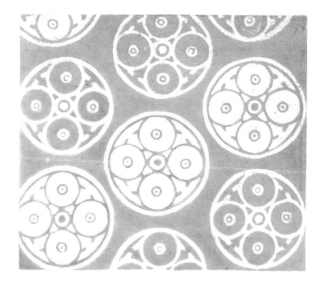

No. 64

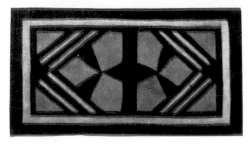

COLOR. XIV — COLOR THEORY NOTAN of COLOR

Teachers College, Ipswich School and Pratt Institute

COLOR. XIV

COLOR THEORY
INTENSITY
Scales and Excercises

No. 65

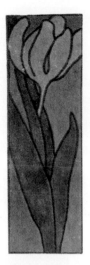
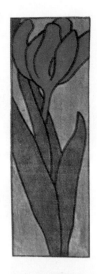

No. 66

COLOR. XV
COLOR DERIVED FROM NOTAN
Students' work – Teachers College, Columbia University, New York

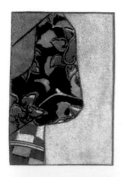
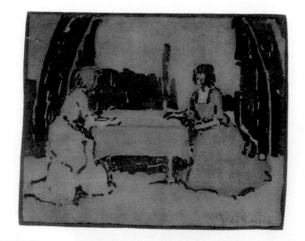
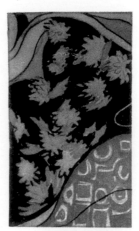
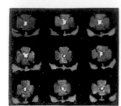

COLOR. XVI No. 67

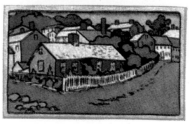

Color Schemes from Japanese Prints — Applications to Design
Students' work – Teachers College, Ipswich School of Art and Pratt Institute

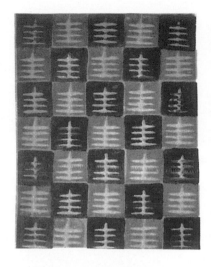
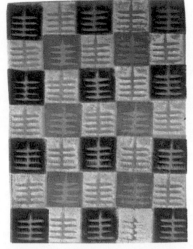
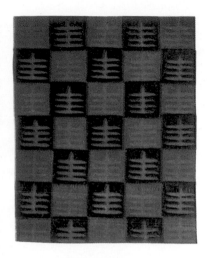
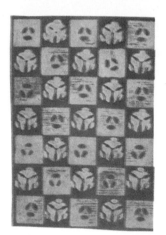
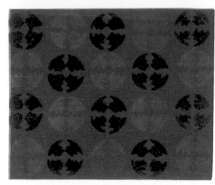
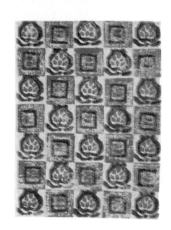

No. 68 COMPOSITION XVII — WOOD BLOCK PRINTING
by students of Teachers College, Columbia University, New York

COMPOSITION XVII.—WOOD BLOCK PRINTING

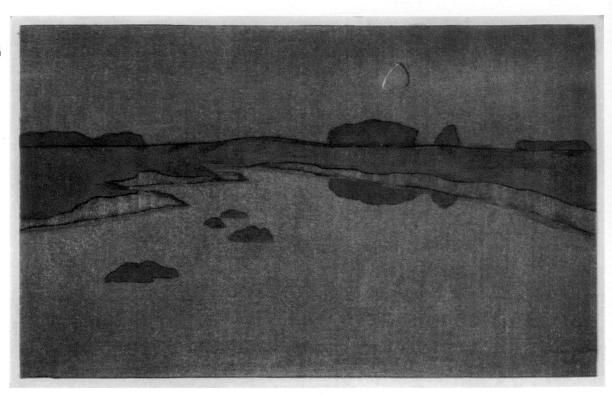

No. 69 THE MARSH CREEK. Wood block print by Arthur W. Dow

NOTAN

IX.—TWO VALUES—VARIATIONS—DESIGN

DARK-AND-LIGHT has not been considered in school curricula, except in its limited application to representation. The study of "light and shade" has for its aim, not the creation of a beautiful idea in terms of contrasting masses of light and dark, but merely the accurate rendering of certain facts of nature,—hence is a scientific rather than an artistic exercise. The pupil who begins in this way will be embarrassed in advanced work by lack of experience in arranging and differentiating tones. Worse than that, it tends to cut him off from the appreciation of one whole class of great works of art. As in the case of Line, so again in this is manifest the narrowness and weakness of the scheme of nature-imitating as a foundation for art education. The Realistic standard always tends to the decay of art.

The student in an academic school, feeling the necessity for a knowledge of Dark-and-Light when he begins to make original compositions, has usually but one resource, that of sketching the "spotting" as he calls it, of good designs and pictures—an excellent practice if followed intelligently. His difficulties may be overcome (1) by seeing that Notan is an element distinct from Line or Color; (2) by attempting its mastery in progressive stages leading to appreciation.

METHOD OF STUDY

Line melts into Tone through the clustering of many lines. Direct study of tone-intervals begins with composition in two values—the simplest form of Notan. There may be several starting-points; one might begin by blotting ink or charcoal upon paper, by copying the darks and lights from photographs of masterpieces, or by making scales. Experience has shown that the straight-line design and the flat black ink wash are most satisfactory for earlier exercises in two values. Instead of black and white, or black and gray, one might use two grays of different values, or two values of one color (say light blue and dark blue) according to need.

The aim being to understand Notan as something by which harmony may be created, it is best to avoid Representation at first. Notan must not be confounded with Light and Shade, Modelling or anything that refers to imitation of natural objects.

The beginner may imagine that not much can be done with flat black against flat white, but let him examine the decorative design of the world. He will find the black and white check and patterns derived from it, in old velvets of Japan, in the woven and printed textiles of all nations, in marble floors, inlaid boxes and archi-

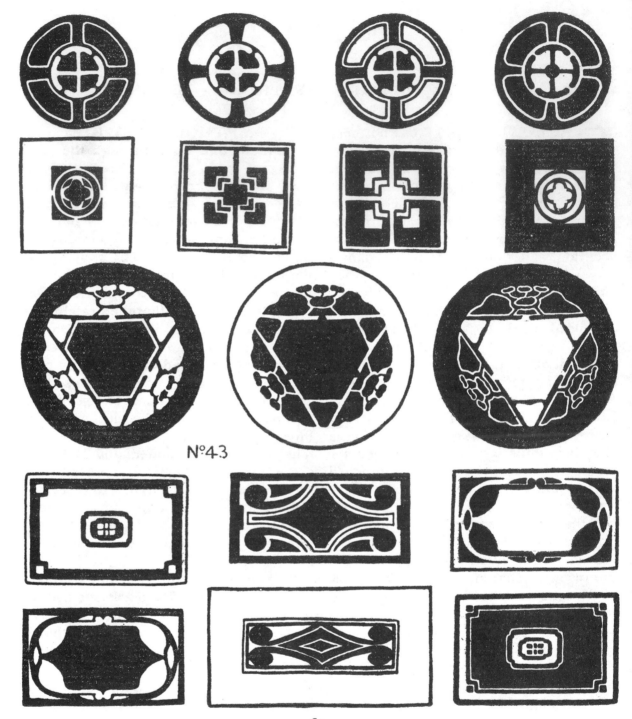

Nº43

tectural ornament. The use of these two simple tones is as universal as Art itself. They appear in the black vine on the white marble floor of the Church of the Miracoli at Venice; on the wall of the Arabian Mosque, and the frieze of the Chinese temple. They have come into favor on book covers and page borders. Aubrey Beardsley went scarcely beyond them. R. Anning Bell and other artists have boldly carried them into pictorial work in the illustration of children's books.

These facts will show the beginner that no terms are too simple for artistic genius to use. Moreover a limited field often stimulates to greater inventive activity.

EXERCISE

Choose a simple line-design fine in proportion, and add to it this new kind of beauty, — as much of it as can be expressed by the extremes of Notan, black against white. It is apparent that we cannot reduce Dark-and-Light to simpler terms than these two values.

The principle of Variation comes into this exercise with special force, for each line-design admits of several Notan arrangements. The student should be given at first a subject with few lines. Let him use one of his own (chapter V), or draw one from the instructor's sketch, but the essential point is to have his design as good as possible in space-proportion before adding the ink.

Make several tracings, then darken certain spaces with black. A round Japanese brush, short and thick, is best for this work. Nos. 43 and 44.

Pupils should be warned against mistaking mere inventive action for art. The teacher must guide the young mind to perceive the difference between creating beautiful patterns, and mere fantastic play.

Those gifted with little æsthetic perception may go far astray in following the two-tone idea. It is very easy and somewhat fascinating to darken parts of designs with black ink. The late poster craze showed to what depth of vulgarity this can be carried. The pupil must be taught that all two-tone arrangements are not fine, and that the very purpose of this exercise is so to develop his appreciation that he may be able to tell the difference between the good, the commonplace, and the ugly. His only guides must be his own innate taste, and his instructor's experience.

No 44

Japanese design for "ramma" (frieze) Fret-saw work

FLOWER COMPOSITIONS
TWO VALUES

Flowers, having great variety of line and proportion, are valuable, as well as convenient subjects for elementary composition. Their forms and colors have furnished themes for painters and sculptors since the beginning of Art, and the treatment has ranged from abstractions to extreme realism; from refinements of lotus-derived friezes to poppy and rose wall papers of the present time. In the exercise here suggested, there is no intention of making a design to apply to anything as decoration, hence there need be no question as to the amount of nature's truth to be introduced. The flower may be rendered realistically, as in some Japanese design, or reduced to an abstraction as in the Greek, without in the least affecting the purpose in view, namely, the setting of floral lines into a space in a fine way — forming a line-scheme on which may be played many notan-variations.

It is essential that the space should be cut by the main lines. (Subordination, page 23.) A small spray in the middle of a big oblong, or disconnected groups of flowers, cannot be called compositions; all the lines and areas must be related one to another by connections and placings, so as to form a beautiful whole. Not a picture of a flower is sought,— that can be left to the botanist—but rather an irregular pattern of lines and spaces, something far beyond the mere drawing of a flower from nature, and laying an oblong over it, or vice versa.

EXERCISE

The instructor chooses one of the best flower compositions done under Line, or draws a flower in large firm outlines on the blackboard, avoiding confusing detail, and giving the character as simply as possible. The pupil first copies the instructor's drawing, then he decides upon the shape into which to compose this subject — a square or rectangle will be best for the beginner. He makes several trial arrangements roughly, with pencil or charcoal. Having chosen the best of these, he improves and refines them, first on his trial paper, and later by tracing with brush and ink on thin Japanese

paper. Effort must be concentrated on the arrangement, not on botanical correctness.

Many line compositions can be derived from one flower subject, but each of these can in turn be made the source of a great variety of designs by carrying the exercise farther, into the field of Dark-and-Light. Paint certain of the areas black, and at once a whole new series suggests itself, from a single line design. To the beauty of the line is added the beauty of opposing and intermingling masses of black and white; see below and p. 64.

In this part of the exercise the arrangement of shapes of light with shapes of dark, occupies the attention, rather than shading, or the rendering of shadows. Hence the flowers and leaves and stems, or parts of them, may be black or white, according to the feeling of the student. Let him choose out of his several drawings those which he considers best. The instructor can then criticise, pointing out the best and the worst, and explaining why they are so. A mere aimless or mechanical blackening of paper, without effort to arrange, will result in nothing of importance.

The examples show the variety of effects produced by flowers of different shapes, and the beauty resulting from schemes of Dark-and-Light in two values.

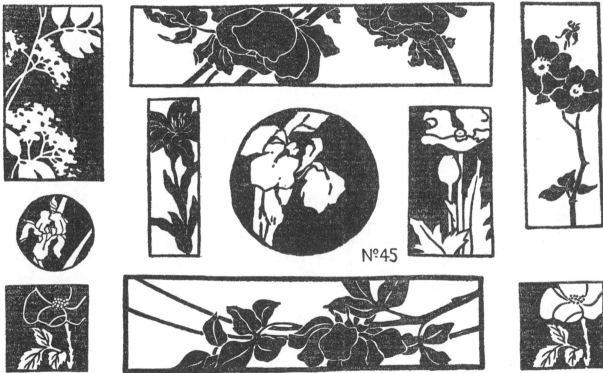

Nº45

Japanese

Japanese

Japanese

Flower compositions, p. 62.

64

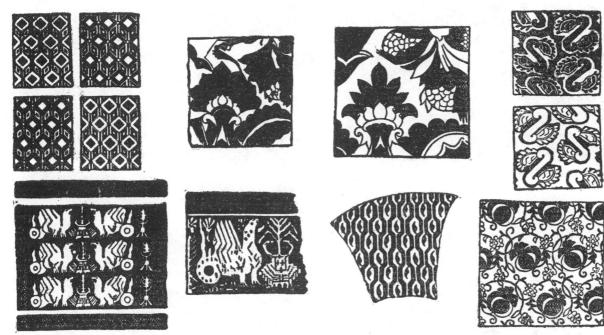

Notan variations on lines of fine old textiles, see p. 67

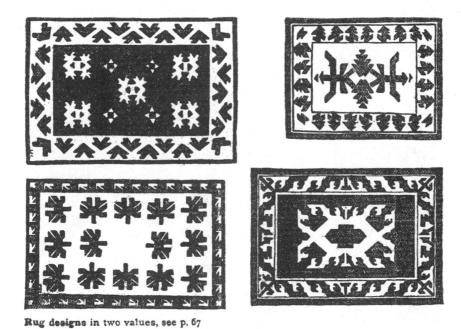

Rug designs in two values, see p. 67

65

From Abruzzi blue towel

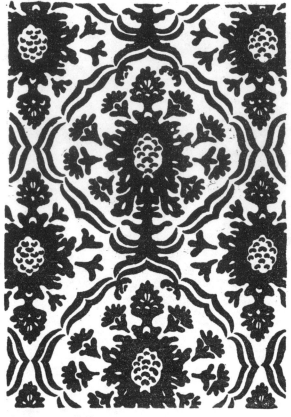

No.46

From Italian Wooten XVI cent.

From Silk brocade, Italian XVII cent.

Japanese, Block print.

From a Khilim rug

Coptic

From a Persian rug

66

TEXTILE PATTERNS AND RUGS TWO VALUES

A line-scheme underlies every notan composition, and a notan-scheme underlies every color composition. The three elements have the closest relation one to another. For purposes of study, however, it is necessary to isolate each element, and even the separate principles of each.

In the present instance, Notan can be separated from Line by taking a line-design of acknowledged excellence and making many Notan variations of it; being sure of beauty of line, the only problem is to create beauty of tone.

As this brings in historic art, let me note that the works of the past are best used, in teaching, as illustrations of composition, (p. 40).

While the knowledge of a " style " may have a commercial value, it has no art-value unless the designer can make original and fine variations of it, not imitations.

The first essential is to appreciate the quality of historic examples, hence the student should work from the objects themselves, from photographic copies, from tracings, or from casts. The commonplace lithographic plates and rude wood cuts in some books of design are useless for our purpose. They give no hint of the original. If the actual painting on an Egyptian mummy case is compared with a page of one of these books, the poor quality of the latter is instantly apparent. Chinese and Japanese " ornament " in most of such books is of a flamboyant and decadent sort.

The facsimile copies of Greek vases usually belong in this same category

EXERCISE

Choose a textile of the best period, say Italian of the XVth or XVIth century; copy or trace the line and play upon this several notan-schemes of two values. You will at once discover how superb the spacing is in these designs, but your main thought is the creation of new dark-and-light ideas upon the fine old pattern; p. 65.

The Oriental rug affords an excellent line-scheme for practice in notan. As composition it is a combination of two principles Subordination and Repetition. Copying a part or the whole of some good rug — in line and color — is the best way to become aquainted with the spacing, motives and quality. Then design a rug with border and centre, the shapes to be pure inventions or symbols. Border and centre must differ, and there are many ways of doing this even in two values, for instance :

Border : Black figures on white ground.
Centre :White figures on black ground.
Border : White figures on black ground.
Centre : Black figures on white ground.
Border : Small figures.
Centre : One large figure.
The illustrations, pp. 65, 66, give some idea of the possibilities of tone-composition in textiles and rugs. The exercise points to one good way of using museum collections and art books.

Nº 47

NOTAN

X.—TWO VALUES—LANDSCAPE AND PICTURES

LANDSCAPE is a good subject for notan-composition, to be treated at first as a design, afterward as a picture. Its irregular spacings contrast well with the symmetries of pattern, and when tones are played over them the effects are new and strange, stimulating to further research into the mysteries of tone. Such an exercise leads to the appreciation of landscape pictures, and is an introduction to pencil and charcoal sketching from nature, to monotypes and etching.

Notan in landscape, a harmony of tone-relations, must not be mistaken for light-and-shadow which is only one effect or accident. Like all other facts of external nature, light-and-shadow must be expressed in art-form. The student under the spell of the academic dictum "Paint what you see and as you see it" feels that he must put down every accidental shadow "just as it is in nature" or be false to himself and false to art. He finds later that accurate record is good and right in studies or sketches but may be wrong in a picture or illustration. No accidents enter into pictures, but every line, light, and dark must be part of a deliberate design.

Light-and-shade is a term referring to modelling or imitation of solidity; the study of it by drawing white casts and still life tends to put attention upon facts rather than upon experience in structure. It does not help one to appreciate tone-values in pictures. Such drawing is worth while as pure representation and the discipline of it contributes to mastery of technique, but it is absurd to prescribe this or life drawing as a training for the landscape painter. Its influence is only indirect, for modeling is of secondary importance in Painting, the art of two dimensions.

When a painter works for roundness and solidity he enters the province of his brother the sculptor. In typical paintings, like Giotto's frescoes at Assisi, Masaccio's " Tribute Money," Piero della Francesca's work at Arezzo, the compositions of the Vivarini, the Bellini and Titian, and even the Strozzi portrait by Raphael, the modelling is subordinate to the greater elements of proportion and dark-and-light.

In a mural painting extreme roundness is a fatal defect, as illustrated in the Pantheon at Paris, where Puvis de Chavannes and his contemporaries have put pictorial designs upon the walls. Puvis created a mosaic of colored spaces intended to beautify the wall; charm of color and tone, poetry and illusion of landscape possess the beholder long before he even thinks of the special subjects. The

other painters made their figures stand out in solid modelling, replacing composition with sculpturesque realities. From these you turn away unsatisfied

I am not arguing for the entire omission of shadows and modelling — they have their place — but am insisting that flat relations of tone and color are of first importance; they are the structural frame, while gradation and shading are the finish. To begin with rounding up forms in light and shade, especially in landscape, is to reverse the natural order, ignore structure, and confuse the mind.

The academic system has adopted the word "decorate" for flat tone relations and non-sculpturesque effects, as if everything not standing out in full relief must belong to decoration. This use of the word is misleading to the student; we do not speak of music and poetry as "decorative". Lines, tones and colors may be used to decorate something, but they may be simply beautiful in themselves, in which case they are no more decorative than music. This word should be dropped from the art vocabulary.

EXERCISE

Choose a landscape with a variety of large and small spaces.

1. Compose this within a border (see Chap. VI.) and when the spacing is good trace with the brush on several sheets of Japanese paper.

Next try the effect of painting certain spaces black, or dark gray, or some dark color like blue. The other spaces may be left white, or painted light gray or with light color. Landscapes are capable of a great many two-value arrangements but not all such will be fine. Strive for harmony rather than number, variety or strangeness. Compare your set and select the best.

2. Compose the landscape into borders of different proportions; then vary each of these in two values.

The illustrations, No. 47, make clear these two ways of working. The student may use the examples given here, then sketch his own subjects from nature.

SPOTTING, — NOTAN OF PICTURES.

When the art student sketches the masses of dark-and-light in pictures, the "Spotting" as he calls it, he is studying Notan of two values, but in an aimless way. He is hunting for some rule or secret scheme of shading, — an "ornament," "bird's wing," a "line;" vain search, for no two works can have the same plan, each has its own individual line and tone.

On the other hand much can be learned by studying the masters' plans of composition, — not to imitate but to appreciate the harmony. One good way to accomplish this is to sketch in the massing, in two values. Choose a number of masterpieces, ancient and modern, and blot in the darks in broad flat tones. This will reveal the general notan-scheme of each picture (pp. 71, 72).

ORIGINAL PICTORIAL COMPOSITION IN TWO VALUES.

The student is now ready for original

E. Manet — On the Beach

(ceiling fresco) Tiepolo — Scuola dei Carmini

Seymour Haden (etching)

A. Mauve,

J. F. Millet Sheep-shearers

Corot

Fortuny — Snake-charmers

Giotto — Joachim and Anna

A. Mauve

Compositions by various masters, reduced to two tones.
"Spotting"

work with landscape, still life or figures. Sketching from nature with brush and ink is a means of interpreting subjects in a very broad way, obliging one to select and reject, to keep only the essentials. It cultivates appreciation of texture and character and brings out the power of doing much with little,—of making a few vigorous strokes convey impressions of form and complexity. It leads to oil painting where the brush-touch must be charged with meaning; it is of direct practical value in illustration as such sketches are effective and easily reproduced. It is almost the only method for painting on pottery, as the absorbent glaze admits of no gradation, emendation or erasure; the touch must be decisive and characterful. Examples of brush-sketching from nature are given in No. 48 on opposite page.

Massing in two values, from Corot, Daubigny and Hokusai

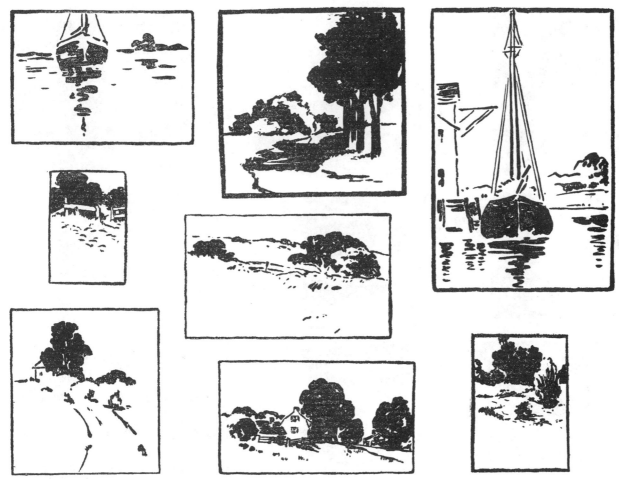

No. 48 Sketches from nature two values

Studies from Gothic Sculpture
Notan of two values

Nº 49

Design for wood-block-printed
pattern — application of two values.
Repetition

NOTAN - Two values Subordination and
Variation of a motif Repetition

NOTAN

XI. — TWO VALUES — GOTHIC SCULPTURE
JAPANESE DESIGN BOOKS.
APPLICATIONS OF TWO VALUES

SCULPTURE, a line-art, when designed to enrich architectural spaces, may have the aid of notan in the form of relief and shadow. The range of tone is narrow and the field seems limited, but the masters have shown that the creative imagination knows no bounds. They have expressed every emotion— divine calm, serenity, excitement, fury, horror; and effects of light, atmosphere, distance.

The pediment and metopes of the Greek temple owed as much to notan as to line; we can infer from the restorations what the original scheme was. Greek architecture, however, did not admit of extensive enrichment with sculpture; there were few spaces to fill, and those not advantageous as to position, shape or lighting. As the temple evolved into the Christian church, the new forms of building and the new story to tell called for sculpture. Through Byzantine and Romanesque it took a fresh start, pushing upward and outward until it flowered abundantly in Gothic. Although the church selected the themes, the sculptor might interpret form and facial expression as his imagination directed, and compose his groups as he chose. Old conventions were abandoned; the artist might now seek motifs in his own mind or in nature. The result of this liberation of individual creative power was great art. The Gothic designer used notan with dramatic invention and magical strangeness. The French cathedrals of the best period (XI to XIV century) notably Paris, Chartres, Amiens and Reims, show how sculptural traditions were boldly broken and the most daring effects accomplished without forgetting the character of stone or the architectural requirements. The stone-cutter was an artist as long as his restraint was self-imposed — as long as he held to unity of the whole composition and kept details in their own place — as long as he carved harmonies, not mere stories; pp. 8, 11, 29, 51, 52.

The masterpieces of Gothic sculpture may be studied from photographs and from reproductions published by the Musée de Sculpture Comparée, Paris.

Sketch in the masses with brush and ink in two values. Draw freely, at arm's length, on gray or low-toned paper, observing the character of shapes of dark; No. 49, opposite. New avenues of tone-thought will now open, through appreciation of the power and beauty of the stone cutter's art of the middle-ages.

Japanese Ramma, Fret-saw work, p. 80

JAPANESE DESIGN BOOKS

If time had preserved for us the sketches of Pheidias, of the architect of St. Mark's, of the great designers of the early ages, we should know how these creators planned the line and mass, the simple structural schemes of their immortal works. In later days when paper was common, artists' drawings were in a less perishable form and many can now be seen in our museums. Some have been published and are fairly within reach, though often in costly editions. But Japanese art comes to the aid of the student of composition with abundant material — sketch books, design books, drawings and color prints. The learner should seek for genuine works of the best periods, avoiding modern bad reproductions, imitations, carelessly re-cut blocks, crude colors, and all the hasty and commonplace stuff prepared by dealers for the foreign market.

The Japanese knew no division into Representative and Decorative; they thought of painting as the art of two dimensions, the art of rhythm and harmony, in which modelling and nature-imitation are subordinate. As in pre-Renaissance times in Europe, the education of the Japanese artist was founded upon composition. Thorough grounding in fundamental principles of spacing, rhythm and notan, gave him the utmost freedom in design. He loved nature and went to her for his subjects, not to imitate. The winding brook with wild iris (above) the wave and spray, the landscape, No. 51, were to him themes for art to be translated into terms of line or dark-and-light or color. They are so much material out of which may be fashioned a harmonious line-system or a sparkling web of black and white.

The Japanese books of most value to the student of composition are those with collections of designs for lacquer, wood, metal and pottery, the Ukiyo-ye books of figures, birds, flowers and landscape, and the books by Kano artists, with brush-sketches of compositions by masters.

It was a common practice with the Japanese to divide a page into sections of equal size and place a different design in each section, p. 55. This is of great im-

Japanese Ramma Fret-saw work, p 80

No. 50

Japanese design for
embroidered kimono

77

No. 51. Japanese landscape compositions for color printing

78

No. 52. Japanese botanical work. Each page a composition in two values

portance to the student for it illustrates at once the principles of space-filling and notan, and gives an idea of the infinite possibilities of artistic invention.

I have reproduced examples from the three classes of books mentioned above, selected in this case for their brilliancy of notan. Let the student copy them enlarged, then make original designs of similar motives. Good reproductions of many Japanese design books can now be obtained at low prices. They are very stimulating, for they point to the best way of studying nature and of translating her beauty into the language of art; pp. 57, 62, 64, 76 — 79.

APPLICATIONS of NOTAN of TWO VALUES

The Structural method of art study places principle before application. Much appreciation of notan could be gained from any one of the subjects just considered, —for example, textiles,— but the tendency would be to think of tone as belonging specially to textiles. The same can be said of Line as it appears in casts, the human form, or historic ornament. Attention is centred upon the particular case, and the larger view is lost. It is better to gain a knowledge of line, mass and color as the material out of which to create; and to become acquainted with principles of harmony-building, before undertaking definite applications. This gives fuller control, and enhances the worker's powers of invention.

Applications of two values are numberless; I will mention a few of them to give the student some clues for original research and experiment.

PRINTING. Florets, seals, initial letters, page ornaments, illustrations, posters, end papers,— drawn in black, gray or one color.

TEXTILES. Blue and white towels, quilts, etc., woven or printed, lace, embroidery, rugs, — pages 9, 65, 66.

KERAMICS. One color on a ground of different value, as blue and white, No. 54; or black on gray.

METAL. Perforated sheet metal; metal for corners, fixtures, etc., pp. 25, 58.

WOOD. Fret saw work, inlay; pp. 62, 76, 77.

Examples of applications are given below, No. 53, and on opposite page.

No. 53

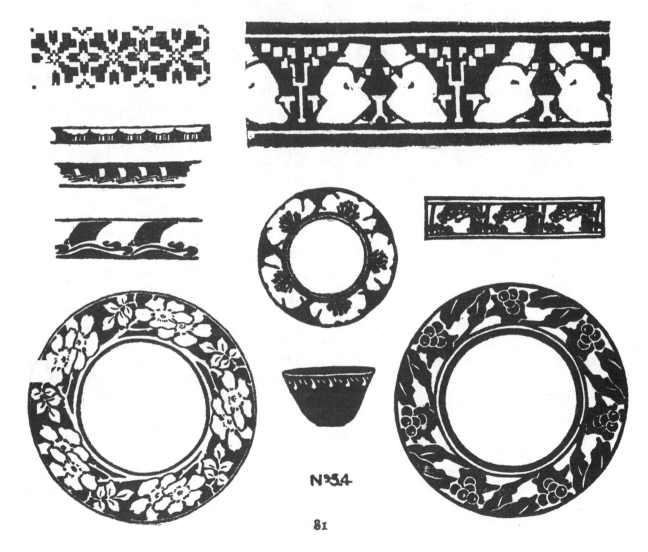

Nº54

81

NOTAN

XII.— THREE VALUES

CLEAR black against clear white is a strong contrast; even the best of such work has some harshness, despite a sparkling brilliancy. A tone of gray, midway between these two extremes, changes their relations and opens up a whole new field for creative activity. Now we must think of different degrees of Notan,—the "value" of one tone against another. This simple set of three notes is the basis of the mezzotint, aquatint, charcoal sketch and wash drawing. The old masters drew on gray paper with black and white.

From three, it is an easy step to many values, and in these refinements of Notan lies the true meaning of the word "values." That property of painted shapes, whereby they "take their places" one beyond another in a picture, is aerial perspective, not values. It is a desirable quality of Representation, and often becomes a kind of deception most agreeable to the mind unappreciative of art. Those who have little perception of harmonies of tone and color, wish to see objects "stand out" in the picture "as if they were real.'

Whistler protested against this, holding that the portrait painter is not an artist unless he can give the opposite effect; that a portrait that stands out beyond its frame is bad.

The word "values" refers to harmony of tone-structure; the value of a mass is its degree of light or dark in relation to its neighbors.

EXERCISE

The student comes now to a new exercise of judgment in determining the middle value between black and white, or between light and dark gray. He has to mix this tone, and decide when it is of the right depth; here, for the first time, he begins to paint.

For this painting-exercise will be needed white dishes in which to mix the ink tones, and flat Japanese (ha-ke) brushes. The best paper is Japanese, well sized. The thin coating of glue keeps the edge of the wash from drying before the brush can take it up.

The first difficulty is the laying of a flat wash; this requires dexterity and much practice. Paper must be stretched or thumb-tacked perfectly smooth; ink-stone, dishes and brushes must be clean. For a beginning take a simple line pattern; decide which parts shall be white; then wash a middle tone of gray over the rest. When dry, paint in the black spaces.

The reason for keeping a tone flat is that the value of a whole space can be judged better; if it is sloppy and uneven it loses force and interest. In beginners' work,

and in design, flatness is necessary, but in picture-painting purely flat tones would rarely be used.

THREE GRAYS, A SCALE

The next step is to mix three values, light, medium and dark, in three white dishes. The intervals can be tested by painting the spaces of a simple scale. This need

White
Middle Gray
Black

not have an outline, as three brush-strokes will suffice.

Apply these tones to a design; make several arrangements, for the effect, and to discover the possibilities in three values. The subjects might be the same as in notan of two values, pages 63 — 68. The examples below illustrate the method and results. See scale, p. 88, also p. 9.

In addition to original composition, the student should copy from masterpieces of design and pictorial art, translating them into three values.

LANDSCAPE AND PICTURES

For three-value studies one may use ink, charcoal or oil paint. The two latter are particularly suitable for landscape designs and illustrative work. Charcoal should be used lightly and very freely. It gives effects of vibration, atmosphere, envelope and light, but the handling requires special study and much practice.

The first few exercises in charcoal landscape may be in flat tones (see No. 55, page 85), and the student may find it well to make a scale of three values in this medium; he must learn however to feel outlines without drawing them, and to handle charcoal firmly but loosely.

Cover the paper with a very sketchy tone of soft charcoal; pass over it lightly with a paper stump or piece of cotton cloth. Be careful not to grind the black into the paper, making an opaque smoky tone. Charcoal paper is made rough, to let the

warm white shine between the little particles of black that lie upon the points of the surface.

When a luminous middle-gray is obtained, sketch in the darks with soft charcoal and take out the lights with bread or rubber; this effect is like a mezzotint, Nos. 55, 57, and p. 57.

After the principle of three values has been demonstrated, and the student can appreciate definite intervals of tone, the instructor should allow great freedom in execution, not even limiting to three notes but adding one or two others if necessary to good expression.

For oil painting, mix the three tones in quantity sufficient to paint several studies. Ivory Black and Burnt Sienna will give a good neutral gray. For the color of blue china or the Abruzzi towels, use Prussian Blue, Black and White. Opinions differ as to the use of diluting mediums, and sizes of brushes, for oil painting. I should advise thinning the color with linseed oil and turpentine (half and half), and using large flat bristle brushes. Canvas should be fairly rough in texture. If the surface to be painted on is smooth,—either wood, pasteboard, or canvas,—prepare a ground with thick paint, leaving brush-marks.

APPLICATIONS, THREE VALUES
Use of the principle of three values in out-door sketching and in illustration, has been explained above. There is one application, among others, that should be made by the student at this point—composition of a book-page.

The usual illustrated page is an arrangement in three tones,—white paper, gray type, dark picture. The value to the publisher depends quite as much upon the picturesque effect of the illustration as upon its drawing. Size and placing, disposition of type, amount of margin, are matters of Line Composition; but choice of type, and the tone of the illustration belong to Notan Composition. Hence the student will gain much from designing pages, in ink, charcoal or oil, using as pictures the copies from masters, or original studies. Picture, title, initial letter, and body of type must be so composed that the result will be effective and harmonious, No. 58.

Reference should be made to examples of early printing, to the works of William Morris, and to the best modern printing.

Japanese drawing, effect of three values

"THE WOLD AFLOAT" by John Sell Cotman

No. 57

"ST. JOHN'S RIVER" by William Morris Hunt

Scales of 5 and 7 values (see p. 89 opposite)

NOTAN

XIII. — MORE THAN THREE VALUES

LINE, Notan, Color — the elements by which the whole visible world is apprehended, — may or may not be used as the language of art. Like speech, this three-fold language may voice noble emotions in poetic style, or may subserve the vulgar and the humdrum. Art-language must be in art-form; a number of facts, or an incident, accurately described in paint and color may have no more connection with art than a similar set of written statements — just plain prose. There is no art unless the statements are bound together in certain subtle relations which we call beauty. When beauty enters, the parts cease to have separate existence, but are melted together in a unit.

Advanced composition is only a working out of simple elements into more complex and difficult interrelations. If the picture has figures and landscape, the lines of each run in such directions, intersect and interweave in such ways as to form a musical movement. The tones and colors are arranged to enrich one another. A noble subject requires noble pictorial style.

Experience of tone-harmony in two and three values brings appreciation of notan-structure and lays a solid foundation for advanced work.

SCALE. At this point construct a scale introducing more delicate relations of tone, and involving finer judgment as to intervals.

A scale of white, black and three grays (a) will be best for beginning, to be followed by a scale of seven values (b). See page 88. These may be made with Japanese ink, water color, charcoal or oil; but not with pencil as it has not depth enough.

The values here are only approximate; perfect accuracy cannot be obtained by the half-tone process.

EXERCISE

Choose a textile, or any design with a variety of spaces, and try notan-effects with tones from the scale. The object is to discover a fine notan-scheme of values, and by using the scale one is assured of definite intervals. If the notes are mixed in quantity, they may be tried upon a half-dozen tracings at once, from which the best should be chosen.

Remember that the scale-work is only an exercise to help toward clarity of tone, and to encourage invention. Harmony of dark-and-light does not depend upon fixed intervals, nor will the composer adhere to any scale in his original creative work.

Some results of this exercise are shown in No. 58, page 91.

ILLUSTRATION

After some experience in handling five or seven tones, the student can undertake original composition. For a beginning pure landscape may be best, taking some of the subjects previously used.

Follow this with landscape and figures; groups of figures with landscape background; figures in interiors; and portrait sketches.

Compose for a book-page, using one light gray value to represent the effect of type, as in No. 58, opposite.

Paint very freely, without too much thought of scales and intervals. Let gradations enter where needed for finer effect. Study the work of the best illustrators, noting the tone-scheme and the placing upon the page.

ETCHING

Etching, pen drawing and pencil sketching are line-arts. The needle, pen and lead pencil are tools for drawing lines, and there is much reason in Whistler's contention that tone and shading should not be attempted with them. The tool always gives character to work, and the best results are obtained when the possibilities of tools and materials are fully appreciated. If a sharp point is used in drawing, it will produce pure line, whose quality may reach any degree of excellence. Whistler, in his etchings, worked for the highest type of line-beauty; shadows and tones were felt, but not expressed.

On the other hand the artist is not subject to restrictions and fixed laws. He cannot allow even a master to interfere with his freedom; there is no " thou shalt " and " thou shalt not " in art. Admitting the value of all the arguments for restricting the use of the needle to line only, the artist observes that clustering of lines inevitably produces tone and suggests massing (notan of line, page 54) that this effect is developed in rich gradations by wiping the etching-plate in the process of printing. Etchers are thus tempted to use tone, and many masters, from Rembrandt down, have worked in tone more often than in line.

PEN DRAWING

is a dry, hard process but one of great value in modern illustration owing to the ease with which it may be reproduced. It need not be as inartistic as it usually appears; observation of pen work will show that, aside from faults in composition, failure in interest lies largely in the handling. Perhaps one pen only is used, and all textures treated alike, whereas every texture should have its own characteristic handling; cross hatching or any uniform system of shading with the pen is deadly. Study the rendering; suggest surface-quality rather than imitate or elaborate; use a variety of pens. Johnston has shown with what art the reed pen may be employed in lettering and illuminating. In comparison with the Japanese brush, the ordinary pen is a clumsy tool, but nevertheless it is capable of much more than is usually gotten with

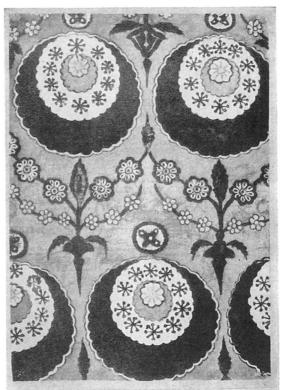

Variation of a textile motif, 3 values, ink

No. 58

The Wade house Ioswich Mass Charcoal study from nature, in 5 values.

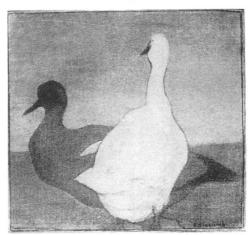

Charcoal study, 4 values

91

Noah's sacrifice

Compositions in more than three values
Pratt Institute, Brooklyn, New York

92

No. 59 **"THE PIRATE SHIP"** Composition in four values, Teachers College, New York

"HARRY MAYNE'S HOUSE" from nature, five values, Ipswich Summer School of Art

Up "Puddin" Street Ipswich 1906 Salem - Custom House from Derby Wharf

No. 60

Evening at Beau- Fenistere
Lath ... churchyard mentioned in "Guatn" Arthur W Dow

it; and the reed pen closely approaches the brush as a line-implement.

The brush may be used as a pen, values and massing being obtained by blots and clustering of lines. Two examples are given below; see also pp. 7, 9, 19.

PENCIL SKETCHING

Much that has been said of etching and pen drawing is equally true of the hard lead pencil; but the soft pencil has many of the qualities of charcoal. It may even be made to resemble the ink wash. The most successful pencil work is that in which line is the main thing, shading being only suggested. These darks, whether meant for shadows, local tone, or color, will form a "spotting" to which is largely due the interest of the sketch.

If shading is attempted, the tones, whether gray or dark, are made by laying lines side by side, not by cross-hatching or going over twice. A pencil sketch must be off-hand, premier coup, brilliant and characterful. Two examples are given as hints for handling, No. 60. It is not possible here to discuss pencil, pen or etching, at length; they are only touched upon in their relation to composition of line and notan.

95

INK PAINTING

Supreme excellence in the use of ink was attained by the Chinese and Japanese masters. Impressionism is by no means a modern art (except as to color-vibrations) for suggestiveness was highly prized in China a thousand years ago. The painter expected the beholder to create with him, in a sense, therefore he put upon paper the fewest possible lines and tones; just enough to cause form, texture and effect to be felt. Every brush-touch must be full-charged with meaning, and useless detail eliminated. Put together all the good points in such a method, and you have the qualities of the highest art; for what more do we require of the master than simplicity, unity, powerful handling, and that mysterious force that lays hold upon the imagination.

Why the Buddhist priests of the Zen sect became painters, and why they chose monochrome are questions involving a knowledge of the doctrines of Buddhism and of the Zen philosophy. It is sufficient to say here that contemplation of the powers and existences of external nature, with a spiritual interpretation of them, was the main occupation of Zen thought. Nature's lessons could be learned by bringing the soul to her, and letting it behold itself as in a mirror; the teaching could be passed on to others by means of art — mainly the art of landscape painting. Religious emotion was the spring of art-power in the East, as it was in the West. Landscape painting as religious art, has its parallel in Greek and Gothic sculpture, in Italian painting of the world-story, of the Nativity, the Passion, and the joys of heaven.

Some of these priest-artists of the Zen, Mokkei, Kakei, Bayen in China; Shubun, Sesshu in Japan, rank with the great painters of all time. They, and such pupils as Sesson, Soami, Motonobu and Tanyu, were classic leaders who have given us the purest types of the art of ink-painting. To them we look for the truly artistic interpretation of nature; for dramatic, mysterious, elusive tone-harmony; for supreme skill in brush-work.

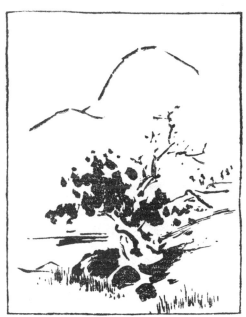

Japanese sketch of the massing in a painting by an old master

Ink-painting is both an art and a craft; it has refinements and possibilities that can be realized only by working with a Japanese artist. He starts with a paper of low tone — it may be its natural state, or he may wash it over with thin ink

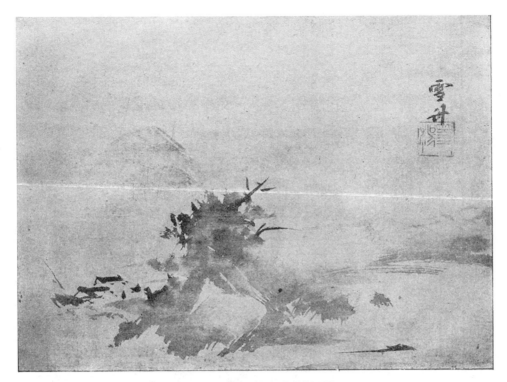

Japanese ink painting by SESSHU, XV. cent.
From the original in the Museum of Fine Arts, Boston

No. 61

Detail of painting by SESSHU, showing quality of brush stroke

97

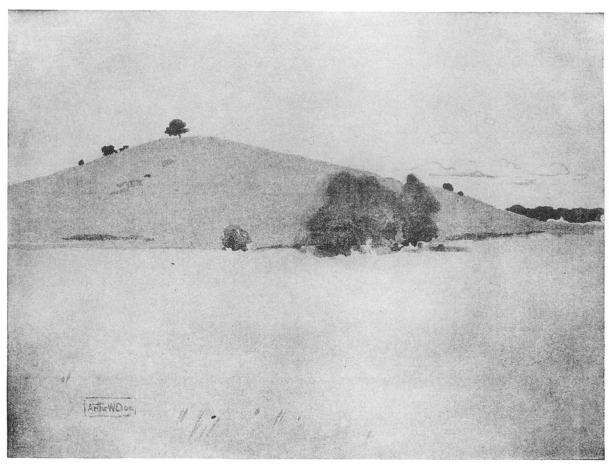

No. 62. AN IPSWICH HILL. Ink painting by Arthur W. Dow

and color. Into this atmospheric undertone he plays gradations, sharp-edged strokes, drops of black, and vibrating washes,— only touching upon forms, but clearly marking planes of aerial perspective. No. 61.

It is not possible for us to attain perfect mastery of Japanese materials and methods, but the study will train in appreciation of tone-composition, and in better handling of our own water color and oil. Good photogravures may now be obtained; in some cases the student may copy from originals in our museums.

For experiments in ink-painting I recommend the Japanese paper called "toshi."

If this is not within reach, a good substitute may be made by sizing manila paper with a thin solution of alum. Japanese paper should be wet, and pasted, by the edges, upon a board. Manila paper, after wetting, may be tacked upon a stretcher. Japanese ink and ink-stone, (Chapter II) round and flat brushes, soft charcoal, and a set of white dishes will be needed. Sketch in the subject lightly with the charcoal, dust it off and draw the main lines with pale thin vermilion water color. Wash in the broad masses, relying upon strengthening by many overtones. Put in the darks last, being very careful that they are not too sharp-edged. No. 62.

Note.— These two sketches and one on p. 96 are from a XVIIth century Japanese book

COLOR

XIV.—COLOR THEORY

COLOR, with its infinity of relations, is baffling; its finer harmonies, like those of music, can be grasped by the appreciations only, not by reasoning or analysis. Color, in art, is a subject not well understood as yet, and there are violent differences of opinion among artists, teachers and critics, as to what constitutes good color-instruction. The most that I can do here is to outline a simple method of study. The usual advice of the academic painter to " keep trying," is discouraging to the beginner and increases his confusion; it is not in accord with good sense either, for the other arts are not attacked through timid and aimless experiment. An artist may say that a certain group of colors is a harmony; the pupil cannot see it, but he takes the master's word for it. The artist is not teaching successfully unless he points the way to appreciation, however hard or long it may be.

A systematic study of line and tone is very profitable, as we have seen; I believe that color may be approached in like manner, and I shall attempt now to relate the treatment of the color-element (chapter I) to that of the other two, and to give some results of personal experience.

Those who have but little time for work in color, can spend it best in copying, under guidance, examples of acknowledged excellence, like Japanese prints, Oriental rugs, and reproductions of masterpieces. Contact with these, even looking at them (if the pupil is taught what to look for), will strengthen the powers of color perception. In schools where the art periods are short and few, this may be the only method possible. (See p. 13 and chap. XVI.)

For those who intend to use color in creative work a certain amount of theory is indispensable, as it simplifies the subject and opens up a few definite lines of research. The word " theory " has become a kind of academic bugbear, yet Leonardo da Vinci said that the painter who works without a theory is like the sailor who goes to sea without a compass. Well-ordered thought is as necessary in art as in any other field. Theory is a help to clear thinking and gives direction and purpose to practice.

Color, however complicated, may be reduced to three simple elements:

HUE,—as yellow, blue-green,

NOTAN (or Value),—as dark red, light red,

INTENSITY (or Bright-to-grayness)—as intense blue, dull blue.

Color harmony depends upon adjustments in this three-fold nature. If a color-scheme is discordant, the fault may

be discovered in,—wrong selection of hues or weak values, or ill-matched intensities, or all three. This simple classification reduces the perplexities that beset the student, by showing him where to look for the cause of failure. The words " Value " and " Chroma " are used in this connection by Albert H. Munsell, to whose book "A Color Notation" the reader is referred for a very convincing exposition of color theory.

Mr. Munsell has invented a photometer to measure values of light and color, and has prepared scales, spheres, charts and pigments for school use.

My own experiments in making circles of hues and scales of notan and intensities, were based upon the old theory —Red, Blue and Yellow as primaries, Green, Orange and Violet as secondaries, etc. At that time (1890) the progression from bright to gray was not recognized as a distinct element of color, but in art-educational works difference of intensity was confused with dark-and-light; spectra for school use contained hues in violent contrast as to brilliancy and value.

Science determined long since that the fundamental color impressions are not red, blue and yellow, but Red, Green and Violet-blue. Mr. Munsell adopts these and two secondaries, Yellow and Purple —five hues in all—as the basis of all color expression in art. This seems very simple and quite sufficient for working out all problems in color scheming.

Note. Experiments as outlined below, are intended only to set the student

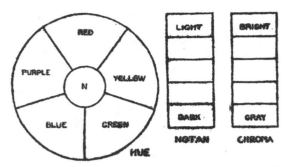

thinking, in an orderly way, about the three dimensions of color.

EXERCISES

HUE. To judge of the effect of one hue upon another, arrange the whole five, Red, Yellow, Green, Blue, Purple, in a circle making them equal in value and equal in degree of brightness, thus eliminating notan and intensity. In the centre of the circle (N) paint a note of middle value, chosen from the scale, p. 88. Then paint the other divisions R, Y, G, B, P with the five hues. When this is well done if the circle were photographed upon a color-blind plate, the result would be a flat tone of middle gray.

No pigment is of the exact quality needed; red that is neither yellow-red nor purple-red can be mixed from Vermilion and Crimson; Prussian Blue is greenish, New Blue is reddish; some pigments are too light, others too dark. This exercise requires study of great importance to the painter, giving him a better acquaintance with his materials.

Next, make a circle of intermediates, No. 63, by mixing adjoining hues; this gives five more notes—yellow-red, green-yellow, blue-green, purple-blue, red-purple. Bear in mind that these circles are

only statements of relations, of the same use as a scale. The question now is of the art-use of them, of composing a harmony with them.

APPLICATION. Choose a line-design, and paint the spaces with colors from the second circle. The effect will be peculiar because there are no differences of dark-and-light or intensity; the only harmony possible comes from interplay of hues, a kind of iridescence and vibration; see opposite page.

Colors that stand opposite in circle — as blue, yellow-red; or red, blue-green — will, if placed side by side, increase each other's power and produce violent contrast. Opposition of Color is analogous to Opposition of Line (page 21) and Opposition of Notan (black and white). To unite these extremes of difference, bring in a third hue related to each, for example, — red, green-yellow, blue-green; yellow, yellow-red, purple-blue. This is the principle of Transition (page 22); see also page 82, three values.

Practice in composing with few and simple elements, of deciding when contrasting colors are of equal value, or equal intensity, is of direct use in art. The landscape painter opposes the whole sky to the whole ground; he wants a vibration of color in each, without disturbing the values; the designer in stained glass sometimes desires to fill a space with iridescent color, perhaps as a background for figures.

The student may, if he likes, use black with these colors, producing a very brilliant effect like a Cairo window; but here the hues are measured against black, rather than against each other.

In No. 63 are shown two experiments in composing with HUE.

NOTAN of COLOR. Draw in outline six scales, as shown in the diagram. Paint N in white, black and three grays (see page 88). In the spaces marked (a) paint each of the five hues — red, yellow, green, blue and purple, middle value and equal intensity.

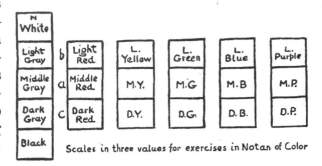

Scales in three values for exercises in Notan of Color

Next, paint a lighter value (b) and a darker (c) making a notan-scale of each hue, — light red, middle red, dark red, etc. Observe that intensity diminishes toward light and dark.

If the intermediates, yellow-red, green-yellow and the rest, are also arranged in this way from light to dark, you will have a set of notes for application in composition.

APPLICATION. A line design may now be colored from one of the scales, say Blue. Hue and Intensity being eliminated, the whole effort is centred upon notan of color. This is an exercise in three values (page 83) using color instead of neutral gray. No. 64, p. 105.

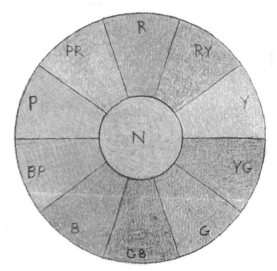

COLOR XIV.

COLOR THEORY
HUE
No. 63

SCALE of 10 HUES and NEUTRAL. Middle Value

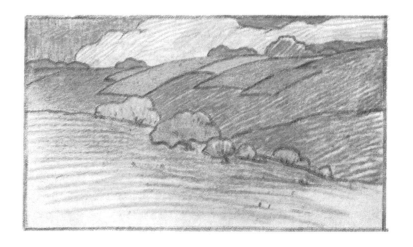

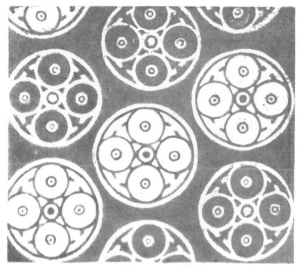

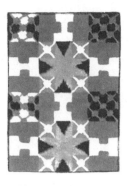

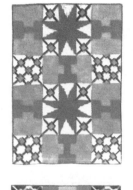

No. 64

COLOR. XIV — COLOR THEORY NOTAN of COLOR

Teachers College, Ipswich School and Pratt Institute

COLOR. XIV

COLOR THEORY
INTENSITY
Scales and Excercises

No. 65

More applications can be made than in the case of Hue; historic art is full of them. Dutch tiles, Japanese prints and blue towels, Abruzzi towels, American blue quilts, etc., are examples of harmony built up with several values of one hue.

With two hues innumerable variations are possible. Japanese prints of the "red and green" period are compositions in light yellow-red, middle green, black, and white. Other examples can be easily found in the world's art. The student should apply the scale-notes to his own designs, not using, at this stage, more than two hues, with perhaps black and white.

INTENSITY. Color varies not only in hue and value, but in intensity,—ranging from bright to gray. Every painter knows that a brilliant bit of color, set in grayer tones of the same or neighboring hues, will illuminate the whole group,— a distinguished and elusive harmony. The fire opal has a single point of intense scarlet, melting into pearl; the clear evening sky is like this when from the sunken sun the red-orange light grades away through yellow and green to steel-gray.

This rarely beautiful quality of color can be better understood by isolating it and testing it in designs (as has been done with each principle, from Line onward; see page 21).

Paint a scale with one hue, say Vermilion, keeping each space of the same value, but grading the intensity down to neutral gray.

APPLICATION. Arrange these notes in a line design. As Hue and Notan are eliminated, the only harmony will be that of bright points floating in grayish tones (No.65). Other hues may be scaled and tested in like manner.

Combine two hues in one design, all values equal,—adding contrast of hue to contrast of intensity.

Examples abound in painting. To cite a few: the element of intensity gives breadth and tonal harmonies in stained glass, Persian rugs, Cazin's foregrounds, the prints of Harunobu, Kiyonaga and Shunsho.

COMPOSITIONS in HUE, NOTAN, INTENSITY. In all color-schemes these three will be found in combination. Analysis of a few compositions will be worth while; for example, the print, No. 69, p. 124, and the print and textile, page 13. Note (1) the number of hues; (2) the number of values of each hue, whether dark, light or medium; (3) the degrees of intensity of each hue, whether very bright, bright, medium or dull; (4) the quantity of each color and its distribution in the design; (5) the amount and effect of black, white and neutral gray.

For a simple exercise in composition the student might color a line design in several ways, using three hues, varying the dark-and-light distribution and the quantity of bright and gray tones.

Follow this with other designs in color. —flower panels, repeating patterns, figures in costume, and landscape. A little of this kind of work will cultivate good

judgment as to color relations, and will stimulate invention. Color Theory does not ensure harmony but is a help toward it, as it shows where balance and adjustment are needed.

Note. It is next to impossible to reproduce colors with perfect accuracy, and even if the hues, values and intensities could be exactly copied, it is doubtful if the inks would remain absolutely un-

changed for a great length of time. The plates of Color Theory here shown are intended only as statements of the fundamental color-relations. They are not scientifically accurate, nor do they need to be,— they are to be used in art, not in science. Their purpose is to show the pupil how to study color, how to make scales and apply them in art, rather than to furnish a standard to be copied.

"THE GUNDALOW" study in three values. See p. 82

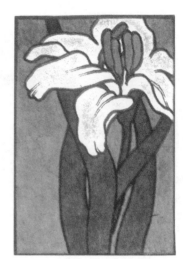

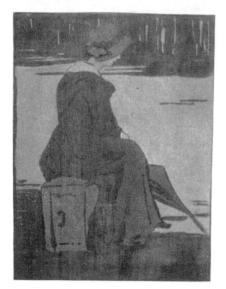

No. 66

COLOR. XV
COLOR DERIVED FROM NOTAN
Students' work – Teachers College, Columbia University, New York

COLOR

XV.— COLOR DERIVED FROM NOTAN

ONE approach to Color may be through Notan, either before or after studying color theory. By clustering lines tone is produced (page 54); by tingeing neutral grays Color is produced. In monochrome itself fine relations of notan will suggest color.

Japanese ink painters enhance the harmonies of tone-composition by mingling slight quantities of hue with the ink. Faint washes of yellow in foregrounds, of green in foliage, of blue in sea and sky, of red and other colors in buildings and costumes, convey impressions of full color-keys.

Etchers and lithographers often add a few touches of color not only as a contrast to the grays, but to cause the beholder to imagine the whole color-scheme.

The effect of modifying neutrals with hue may be observed in the following

EXERCISE

Prepare a set of three gray washes, light, medium, and dark (page 83) in three white dishes. Japanese ink will not mix with our water colors; use Ivory Black with a touch of Burnt Sienna to bring it to neutrality.

Having settled upon a color arrangement for some simple design, mix a small quantity of color into each dish.

Suppose the subject to be a tulip panel in three values:

1. Leaves — middle yellow-green
2. Flower — middle red-yellow
3. Background — light yellow

Add to 1st dish a yellow green (Prussian Blue and Gamboge); to the 2nd Vermilion and Gamboge; to the 3rd Raw Sienna. Paint these notes upon the design. (See opposite page.)

Make a half dozen tracings of the same design. As each one is painted add more color to the washes until the last one has a very small quantity of gray. The result is a series in which color grows gradually from neutrals. No. 66. Next, use bright and gray tones of the same hue, an effect like faded rugs and age-stained Japanese prints.

Dulling colors with gray may not harmonize them. One who appreciates fine quality is not deceived by those who "antique" rugs or prints with coffee and chemicals. A design poor in proportion, weak in notan and harsh in color cannot be saved by toning — the faults are only a little less apparent.

ONE HUE and NEUTRALS. Another approach to color, from notan, is through substitution of hues for grays. This might (in a short course) follow exercises in five or more values (page 89.) Referring now to the scales of five and seven values, for application to a design,

substitute a hue for one of these grays, carefully keeping the value. If the subject be a variation of a Coptic textile, a warm red or yellow-green may be chosen; for a flower panel, bright yellow, yellow-red or emerald green. Excellence in result will depend upon distribution of the one hue among neutral tones.

Examples are many; two kinds only need be mentioned now,— American Indian pottery, and landscapes in black, gray and vermilion red from Hokusai's "Mangwa," (p. 57.)

ONE HUE in TWO and THREE VALUES. The next step would be to replace two grays with two values of one hue, making scales like these:

White	White
Light green	Light purple
Middle green	Middle gray
Dark gray	Dark purple
Black	Black

Follow by eliminating all the grays, and the scale might be like this:

White
Light blue-green
Middle blue-green
Dark blue-green
Black

Choice of color will depend upon the nature of the design.

The medium may be crayon, wash, opaque water color or oil paint.

TWO and THREE HUES. If two hues are introduced the complexity will be greater, but there will be more chances for invention and variation. With at least ten hues to choose from — R, YR, Y, GY, G, BG, B, PB, P, RP—each one of which might have perhaps four degrees of intensity (from very bright to dull) the student has material to compose in any key. Two typical scales are given below:

Two hues — White
Light yellow
Middle gray
Dark green
Black

Three hues — White
Light yellow
Middle gray-green
Dark gray-purple
Black

HARMONY

Will the exercises in the foregoing chapters ensure a harmony? No, they are only helps to a better understanding of color. Harmony depends upon (a) good line design, (b) choice of hues, (c) quantity of each, (d) a dominating color, (e) notan values, (f) fine relations of intensity, (g) quality of surface, (h) handling. All these in perfect synthesis will be found in the works of the greatest masters. It is also true that simple harmonies are not difficult to realize, as is witnessed by primitive art and the best work of students.

With practice in the ways suggested here, two other things are necessary,— advice from an experienced and appreciative instructor, and acquaintance with fine examples of color.

Credit Card Purchase
Literary Guillotine
204 Locust St.
Santa Cruz, CA 95060
(831) 457-1195

11/16/2017 10:21:04 AM
Invoice # 254138
Cashier ID: 01
Station ID: 2
of items: 1
==
Composition
048646007X 1 @ $18.95 $18.95
==
Sub Total $18.95
Tax 1 Total $1.71
Grand Total $20.66

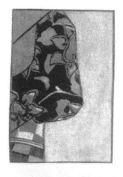
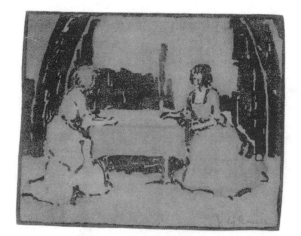

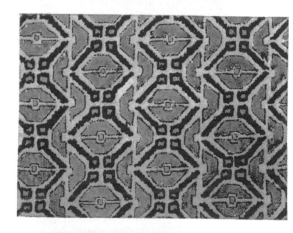

COLOR. XVI

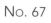

No. 67

Color Schemes from Japanese Prints — Applications to Design
Students' work – Teachers College, Ipswich School of Art and Pratt Institute

COLOR

XVI. — COLOR SCHEMES FROM JAPANESE PRINTS AND FROM TEXTILES

IN the quest for harmony, what better course could be taken than to copy harmonies? Nothing so sharpens color perception as contact with the best examples. The attempt to reach a master's style, peculiar color-feeling, refinements of tone and methods of handling, brings both knowledge and appreciation. For ordinary use Japanese prints are most convenient and inspiring color-models.

COPYING JAPANESE PRINTS. In the best of these the color has a peculiar bloom due to the process of printing from wood blocks. The paper is pressed upon forms cut on the flat side of a board; the grain of the wood, the rough surface of the "baren" with which the paper is rubbed down, and the fibrous texture of the paper combine to make a luminous vibrating tone. Particles of color lie upon the tops of silken filaments, allowing the undertone of the paper to shine through, — precisely the quality sought by painters in using a rough canvas and thin washes, or thick color put on with small brushes. In the print the vibration is not obvious, but the effect is that of color over which floats a thin golden envelope.

Ordinary charcoal paper is good for copies, as it has a roughness that aids in producing atmospheric tones. Rub a slight quantity of charcoal over the surface, very lightly; wipe it off with chamois or cotton rag, leaving little points of black in the hollows of the paper.

Isolate the desired color-passage, by cutting an opening in a sheet of white paper and laying it upon the face of the print. Copy with washes of water color. If the print is age-stained, tone your charcoal paper with Raw Sienna and Ivory Black.

AUTHORS. Good color-schemes can be found anywhere in the range of Japanese color-printing, from Okumura Masanobu in the middle of the XVIIIth century to modern days, but the rarity and great value of early prints puts them out of reach of those who have not access to museum collections. I can mention here but a few names, with which the student is most likely to meet:

Torii Kiyonobu and his fellows of the "red-and-green period" (first half of the XVIIIth century); Harunobu, Koriusai, Kiyonaga and Shunsho, who worked in sunny yellows and reds, pearly greens and pale purples, often most cleverly opposed with transparent black and cool silvery grays; then Utamaro and Toyokuni I., strong but less fine.

Among XIXth century men Hiroshige (page 13) and Hokusai are preëminent

as colorists. Both have strongly influenced Occidental painters.

Hiroshige designed series after series of prints, — scenes famous for their beauty or historic interest; stations on the two great highways, the Tokaido and the Kisokaido; effects of wind, rain, snow and twilight; flowers, birds, and a few figures. He would recompose the same series again and again in different size and color-scheme. His design is full of delightful surprises; his artistic power and inventiveness are astonishing. A prodigious amount of work is signed by his name; some critics hold that there was a second, and even a third Hiroshige, but Fenollosa believed in one only, whose manner naturally varied during a long life (1790 — 1858).

Hokusai's color is strange and imaginative; sometimes delicate almost to neutrality, sometimes startling and daring. His pupils Hokkei, Hokuju and the rest are more gentle.

The figure prints most commonly seen are by Kunisada (Toyokuni II), Kuniyoshi and other pupils of Toyokuni I., and Keisai Yeisen. Here, as in most Japanese figure prints, color effects are produced by skilful combinations of patterns upon costumes. Every kind of color-key is possible, by this means, with infinite variations; — impressionist painting with wood blocks.

The student is warned that poor prints abound, — impressions from worn-out blocks, cheap modern reprints, and imitations. Bright, fresh color, however, need not be taken to mean imitation;

some of the early editions have been kept in albums in store houses, and the color has not changed. Experience and appreciation are after all the only safeguards.

APPLICATION. Having made the copy of the color-scheme, apply the same colors to several tracings of one design, (No. 67). One of the things taught by this exercise is that distribution and proportion of color affect harmonic relations. Colors that harmonize as they stand in the print may seem discordant when used in different quantities; they will surely be so if the design is badly spaced. With a good design, and correct judgment as to hue, notan and intensity, the chances are that each variation will be satisfactory.

Copies from Hiroshige are of special value to the landscape painter. These may be made in oil as a study of quality and vibration. The procedure is a little different from the preceding. It is better, in oil painting, to copy whole prints. Over the surface of a large rough canvas scrub a thin gray, of the color of the paper of the print. Draw the design in a few vigorous lines, omitting all details. Paint in, at arm's length, the principal color notes, not covering the whole surface or filling in outlines. Mix colors beforehand, taking time to copy each hue and value exactly. The painting, with each color ready upon the palette, should be swift and vigorous. Place the print above the canvas; stand while painting; make comparisons at a distance.

Copying Japanese prints is recommended for practice in color; it does not replace nature-painting or original design, though it will be a help to both.

COPYING COLOR from TEXTILES. The exercises described above may be taken with textiles. Beauty of color in the finest of these is due to good composition, the softening of dust and age-stain, and the atmospheric envelope caused by reflection of light from the minute points of the web. For some kinds of textile the charcoal paper, as above, may be useful; for others, gray paper and wax crayons.

The latter are excellent for copying rugs and can be used in original designs for rugs.

As to models, work from originals in museums,—Persian carpets and rugs, Coptic and Peruvian tapestries, mediæval tapestries, Italian, Spanish and French textiles XIIIth to XVIIIth centuries, etc. In the "rag-fairs" of Europe, and in antique shops, one may find scraps of the woven and printed stuffs of the best periods.

The South Kensington Museum has published colored reproductions of textiles. Art libraries will have Fischbach's, Mumford's, the Kelekian Collection and others in full color.

COMPOSITION

XVII. — IN DESIGN AND PAINTING

THE test of any system of art-study lies in what you can do with it. Harmony-building has been the theme of the foregoing pages, with progressive exercises in structural line, dark-and-light and color. The product should be power, — power to appreciate, power to do something worth while. Practice in simple harmonies gives control of the more complex relations, and enables one to create with freedom in any field of art. Such training is the best foundation for work in design, architecture, the crafts, painting, sculpture and teaching. After this should come special training; for the designer, architect, craftsman, study of historic styles, severe drill in drawing (freehand and mechanical), knowledge of materials; for the painter and sculptor, long practice in drawing and modelling, acquirement of technique; for the teacher, drill in drawing, painting, designing and modelling, study of educational principles, knowledge of school conditions and public needs, practice teaching.

In a word, first cultivate the mind, set the thoughts in order, utilize the power within; then the eye and the hand can be trained effectively, with a definite end in view. The usual way, in our systems of art-instruction, is to put drill first, leaving thought and appreciation out of account.

Applications of structural principles are many; I can mention and illustrate but a few:

WOOD BLOCK PRINTING
FOR STUDY OF PATTERN AND COLOR

The art of wood block printing has been practised for ages in Oriental countries. Our word "calico" is from the name of an Indian town, Calicut, whence printed patterns were brought to England. The older Indian designs, now very rare, had great beauty of line and color.

These ancient cotton prints are used by the Japanese for outer coverings of pieces of precious pottery,— first a silk brocade bag, then one of Indian calico enveloping a wooden box in which is the bowl wrapped in plain cotton cloth.

The process of wood block printing is very simple, and in my opinion of special educational value. After observation of the craft in India in 1904 I determined to introduce it into art courses — both for adults and children. The method is outlined below:

1. Design the pattern in pencil or ink.
2. Draw the unit, with attention to its shape and proportions and the effect when repeated.
3. Paste this face down upon a wood block; pine, gum wood, or a hard wood of close grain.

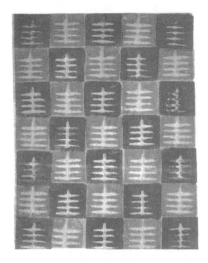
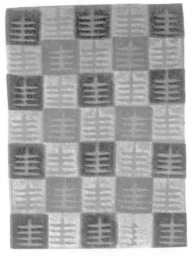
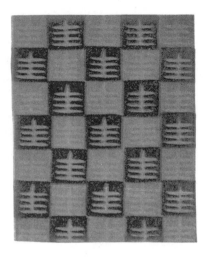
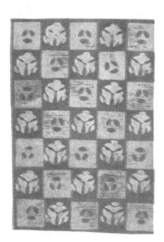
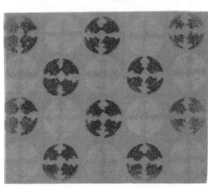
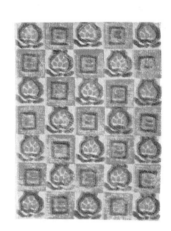

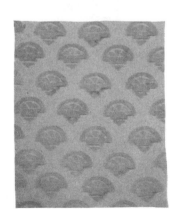

No. 68 COMPOSITION XVII — WOOD BLOCK PRINTING
by students of Teachers College, Columbia University, New York

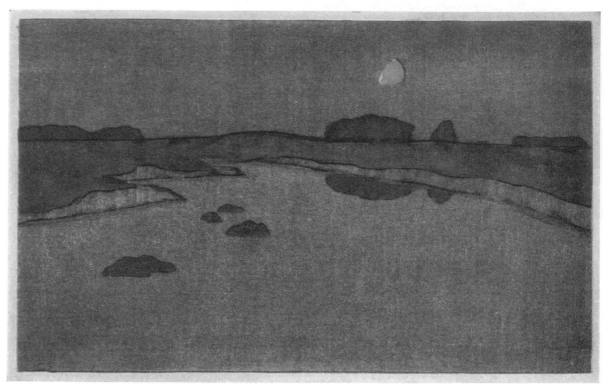

No. 69 THE MARSH CREEK. Wood block print by Arthur W. Dow

4. Cut away the white spaces, clearing with a gouge. As the block is to be used as a stamp, the corners and all outside the design, must be removed.

5. Printing. Lay a piece of felt upon a slate, or upon a glass, pour a few drops of mucilage upon the felt, and mix with it either common water color, or dry color. Distribute this evenly with a flat bristle brush.

Make a large pad, say 22 x 28 or 14 x 20, by tacking cambric upon a drawing board. Under the cambric should be one thickness of felt.

PRINTING on PAPER.

A slightly rough absorbent surface prints well. Wrapping paper can be found in many colors, tones and textures, and is inexpensive. Damp paper will give clear-cut impressions.

Lay the paper upon the large pad; charge the block upon the small pad, and stamp the pattern. If the impression is poor, the cause may be:—(a) Face of block is not level; rub it upon a sheet of fine sand-paper; (b) large pad is uneven; (c) paper is wrinkled or is too glossy; (d) color is too thick or too wet. Practice will overcome these small difficulties.

PRINTING on CLOTH.

The best effects are obtained with dyes, but their manipulation is not easy, and their permanence is doubtful unless one has expert knowledge of the processes of dyeing. The most convenient medium for the student is oil color thinned with turpentine (to which may be added a very little acetic acid and oil of wintergreen). This, when dry, is permanent and can be washed,—but not with hot water or strong soap.

With the design in fixed form upon the block, effort can be concentrated upon the make-up of the pattern, and the color-harmony. By cutting a block for each color the designer may vary the scheme almost to infinity. Where choices are many and corrections easy, invention can have free play.

Examples of students' printing on paper are given on page 121.

PICTURE PRINTING

is a more difficult, but fascinating form of this art-craft. Here must be gradation, transparent and vibrating color, atmospheric over-tone binding all together. For these qualities the Japanese process is best, with its perfected tools and methods. In theory it is very simple: The outline is drawn in ink upon thin paper, and the sheet pasted face down upon the flat side of a board; the block is then engraved with a knife and gouges, the drawing being left in relief; the paper is removed from the lines with a damp cloth, and the block charged with ink. Dry black mixed with mucilage and water, or any black water color will answer. For charging, the Japanese use a thick short brush,—a round bristle brush will serve the purpose. When ink is scrubbed evenly over the whole surface, the block is ready for printing. A sheet of Japanese paper, slightly damp-

125

ened, is laid upon the block and rubbed gently with a circular pad called a "baren." This wonderful instrument draws the ink up into the paper, giving a clear rich soft line.

The baren is made of a leaf of bamboo stretched over a saucer-like disk of pasteboard, within which is coiled a braided fibre-mat.

If the block has been properly cleared, and the baren is moved in level sweeps, the paper will not be soiled by ink between the lines. After printing a number of outlines the colors are painted upon them and color-blocks engraved. It is possible to have several colors upon the same board, if widely separated. Accurate registry is obtained by two marks at the top of the board and one at the side. The paper must be kept of the same degree of moisture, otherwise it will shrink and the last impressions will be out of register.

Dry colors mixed with water and a little mucilage, or better still, common water colors, may be used. No. 69 is a reproduction of a print made in the Japanese way. (In 1895 I exhibited at the Boston Museum of Fine Arts a collection of my wood block prints. Professor Fenollosa wrote the introduction to the catalogue, discussing the possibilities, for color and design, of this method, then new to America. In "Modern Art" for July, 1896, I described the process in full, with illustrations, one in color.)

STENCILLING, like wood block printing, invites variation of rhythm and col-

or combination. Stencilling is often done without sufficient knowledge of the craft. The student should understand that a stencil is simply a piece of perforated water proof paper or metal to be laid upon paper or cloth and scrubbed over with a thick brush charged with color; long openings must be bridged with "ties," and all openings must be so shaped that their edges will remain flat when the brush passes over them.

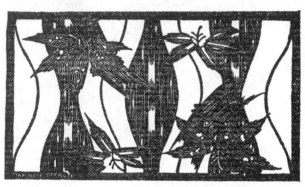

Stencil units are usually large, offering good opportunities for Subordination (page 23), Symmetry, and Proportion (page 28). A unit must not only be complete in itself but must harmonize with itself in Repetition (pp. 36, 66).

Stencils may be cut upon thick manila paper which is then coated with shellac; or upon oiled paper. If stencil brushes cannot be obtained one may use a common, round, house-painter's brush, wound with string to within an inch of the end.

Colors may be,—oil thinned with turpentine; dyes; or dry colors ground on a slab with water and mucilage. Charge the brush with thin, thoroughly mixed

pigment; if there is too much it will scrape off under the edges of the stencil and spoil the print.

Unprinted wall paper ("lining paper") is cheap and very satisfactory for stencilling. It should be tinted with a thin solution of color to which a little mucilage has been added. Use a large flat brush about four inches wide, applying the color with rapid vertical and horizontal strokes.

COLORED CHARCOAL.

This is a further development of the method described in Chapter XIII (see also page 113). Lay in the picture in light values of charcoal, remembering that the color-washes will darken every tone. Too much rubbing with the stump gives muddiness, too little charcoal may weaken the values and you will have a "wash-out." When the notan-scheme is right, the drawing may be fixed. It can be colored without fixing if the stump has been used.

Color is applied in thin washes allowing the charcoal texture to shine through. Notan plays the larger part, furnishing the structure of the composition and giving a harmonic basis for the color. If the hues are well-chosen, the result should be a harmony of atmospheric depth, with soft but glowing colors.

PAINTING in FULL COLOR.

In a book devoted to the study of art-structure not much space can be given to comparison of mediums, or to professional problems of technique in advanced painting. They will be mentioned to show the unity of the progressive series, to suggest to the student some lines of research and experiment, and to help him in choosing his field of art-work.

WATER COLOR.

This medium is used in many different ways: as a thin transparent stain, like the work of David Cox, Cotman, De Wint; as a combination of opaque color and wash, with which J. M. W. Turner painted air, distance, infinity, the play of light over the world; as flat wash filling in outlines, like the drawings of Millet and Boutet de Monvel; as the modern Dutch use it, in opaque pastel-like strokes on gray paper, or scrubbed in with a bristle brush; as premier coup painting with no outline (both drawing and painting) like much Japanese work.

In all these, line is the basis, whether actually drawn, as by Millet and Rembrandt, or felt, as by the Japanese and Turner. The best painting has form and character in every brush-touch.

OIL COLOR.

Instruction in oil painting is usually limited to what might be called drawing in paint. Of course the student must know his pigments, how to obtain hues and values by mixing, how to use brushes, how to sketch in, and all the elementary details,—but this is but a beginning. Expression of an idea or emotion depends upon appreciation of art structure; the point is not so much

how to paint, as how to paint well. Artists often say that it matters not how you get an effect, if you only get it. This is misleading; it does matter,—the greatest painters get their effects in a fine way.

Methods of handling oil color may be reduced to two general classes: (a) the paint is used thin, as a wash, on a prepared canvas, or (b) it is put on in thick opaque touches. In either case the aim is the same—to paint for depth, vibration, illusion of light and color. If brush strokes are to be left intact, each of them must have shape and meaning,—that is, line; if color is put on in a thin wash, then its value, gradation, hue and texture are the main points,—and these belong to structural harmony.

Mural painting is the highest form of the art, demanding perfect mastery of Composition. The subject takes visible form in terms of Line; then is added the mystery, the dramatic counter-play of Notan, and the illumination of Color. The creative spirit moves onward absorbing in its march all drawing, perspective, anatomy, principles of design, color theory —everything contributing to Power.

CONCLUSION

I have not attempted to overthrow old systems, but have pointed out their faults while trying to present a consistent scheme of art study. The intention has been to reveal the sources of power; to show the student how to look within for the greatest help; to teach him not to depend on externals, not to lean too much on anything or anybody.

Each subject has been treated suggestively rather than exhaustively, pointing out ways of enlargement and wide application. If some subjects have seemed to receive rather scant attention it is not because I am indifferent to them, but because I did not wish to depart from the special theme of the book; some of these will be considered in future writings. The book will have accomplished its purpose if I have made clear the character and meaning of art structure — if the student can see that out of a harmony of two lines may grow a Parthenon pediment or a Sorbonne hemicycle; out of the rude dish of the Zuni a Sung teabowl, out of the totem-pole a Michelangelo's " Moses "; that anything in art is possible when freedom is given to the divine gift APPRECIATION

THE END

Art Instruction

CALLIGRAPHY, Arthur Baker. Generous sampling of work by foremost modern calligrapher: single letters, words, sentences, ventures into abstract and Oriental calligraphy, and more. Over 100 original alphabets. Foreword by Tommy Thompson. 160pp. 11⅜ x 8¼. 0-486-40950-3

THE ARTIST'S GUIDE TO ANIMAL ANATOMY, Gottfried Bammes. A systematic approach to learning proportion, rules of repose and motion, and basic forms. Students learn how to modify drawings of a horse and cow to portray a dog, lion, and other subjects—in poses ranging from static to rapidly moving. 78 figures in color; 71 b/w illustrations. 143pp. 8⅜ x 11.
0-486-43640-3

PRACTICAL GUIDE TO ETCHING AND OTHER INTAGLIO PRINTMAKING TECHNIQUES, Manly Banister. Detailed illustrated instruction in etching, engraving, aquatint, drypoint, and mezzotint—from preparing plate to mounting print. No better guide for beginners. 128pp. 8⅜ x 11¼.
0-486-25165-9

ILLUSTRATING NATURE: HOW TO PAINT AND DRAW PLANTS AND ANIMALS, Dorothea Barlowe and Sy Barlowe. Practical suggestions for the realistic depiction of natural subjects. Includes step-by-step demonstrations using a variety of media. More than 400 illustrations; great for pros or amateurs. 128pp. 8¼ x 10½. 0-486-29921-X

ACRYLIC WATERCOLOR PAINTING, Wendon Blake. Excellent step-by-step coverage of painting surfaces, colors, and mediums as well as basic techniques: washes, wet-in-wet, drybrush, scumbling, opaque, and more. 75 paintings demonstrate extraordinary variety of techniques. 105 black-and-white illustrations. 32 color plates. 152pp. 8⅜ x 11¼. 0-486-29912-0

FIGURE DRAWING STEP BY STEP, Wendon Blake. Profusely illustrated volume provides thorough exposition of figure drawing. More than 175 illustrations accompany demonstrations, showing how to establish major forms, refine lines, block in broad shadow areas, and finish the work. 80pp. 8⅜ x 11.
0-486-40200-2

OIL PORTRAITS STEP BY STEP, Wendon Blake. A wealth of detailed, practical advice and valuable insights on basic techniques; planning, composing, and lighting the portrait; working with other media, and more. More than 120 illustrations (including 57 in full color) act as step-by-step guides to painting a variety of male and female subjects. 64pp. 8⅜ x 11¼.
0-486-40279-7

PEN AND PENCIL DRAWING TECHNIQUES, Harry Borgman. Manual by acclaimed artist contains the best information available on pencil and ink techniques, including 28 step-by-step demonstrations—many of them in full color. 256pp., including 48 in color. 474 black-and-white illustrations and 73 color illustrations. 8⅜ x 11. 0-486-41801-4

CONSTRUCTIVE ANATOMY, George B. Bridgman. More than 500 illustrations; thorough instructional text. 170pp. 6½ x 9¼. 0-486-21104-5

DRAWING THE DRAPED FIGURE, George B. Bridgman. One of the foremost drawing teachers shows how to render seven different kinds of folds: pipe, zigzag, spiral, half-lock, diaper pattern, drop, and inert. 200 b/w illustrations. 64pp. 6½ x 9¼. 0-486-41802-2

ANIMAL SKETCHING, Alexander Calder. Undisputed master of the simple expressive line. 141 full body sketches and enlarged details of animals in characteristic poses and movements. 62pp. 5⅜ x 8½. 0-486-20129-5

CHINESE PAINTING TECHNIQUES, Alison Stilwell Cameron. The first guide to unify the philosophical and imitative methods of instruction in the art of Chinese painting explains the tools of the art and basic strokes and demonstrates their use to represent trees, flowers, boats, and other subjects. Hundreds of illustrations. 232pp. 9¼ x 9. 0-486-40708-X

LEARN TO DRAW COMICS, George Leonard Carlson. User-friendly guide from 1930s offers wealth of practical advice, with abundant illustrations and nontechnical prose. Creating expressions, attaining proportion, applying perspective, depicting anatomy, simple shading, achieving consistency, characterization, drawing children and animals, lettering, and more. 64pp. 8⅜ x 11. 0-486-42311-5

CARLSON'S GUIDE TO LANDSCAPE PAINTING, John F. Carlson. Authoritative, comprehensive guide covers every aspect of landscape painting; 34 reproductions of paintings by author. 58 explanatory diagrams. 144pp. 8⅜ x 11. 0-486-22927-0

YOU CAN DRAW CARTOONS, Lou Darvas. Generously illustrated, user-friendly guide by popular illustrator presents abundance of valuable pointers for both beginners and experienced cartoonists: pen and brush handling; coloring and patterns; perspective; depicting people, animals, expressions, and clothing; how to indicate motion; use of comic gimmicks and props; caricatures; political and sports cartooning; and more. viii+152pp. 8⅜ x 11.
0-486-42604-1

PATTERN DESIGN, Lewis F. Day. Master techniques for using pattern in wide range of design applications including architectural, textiles, print, and more. Absolute wealth of technical information. 272 illustrations. x+306pp. 5⅜ x 8½.
0-486-40709-8

COLOR YOUR OWN DEGAS PAINTINGS, Edgar Degas (adapted by Marty Noble). Excellent adaptations of 30 works by renowned French Impressionist–among them *A Woman with Chrysanthemums, Dancer Resting,* and *The Procession (At the Race Course).* 32pp. 8¼ x 11. 0-486-42376-X

METHODS AND MATERIALS OF PAINTING OF THE GREAT SCHOOLS AND MASTERS, Sir Charles Lock Eastlake. Foremost expert offers detailed discussions of methods from Greek and Roman times to the 18th century–including such masters as Leonardo, Raphael, Perugino, Correggio, Andrea del Sarto, and many others. 1,024pp. 5⅜ x 8½. 0-486-41726-3

THE ART AND TECHNIQUE OF PEN DRAWING, G. Montague Ellwood. Excellent reference describes line technique; drawing the figure, face, and hands; humorous illustration; pen drawing for advertisers; landscape and architectural illustration; and more. Drawings by Dürer, Holbein, Doré, Rackham, Beardsley, Klinger, and other masters. 161 figures. x+212pp. 5⅜ x 8½. 0-486-42605-X

ART STUDENTS' ANATOMY, Edmond J. Farris. Long a favorite in art schools. Basic elements, common positions and actions. Full text, 158 illustrations. 159pp. 5⅜ x 8½. 0-486-20744-7

ABSTRACT DESIGN AND HOW TO CREATE IT, Amor Fenn. Profusely illustrated guide covers geometric basis of design, implements and their use, borders, textile patterns, nature study and treatment. More than 380 illustrations include historical examples from many cultures and periods. 224pp. 5⅜ x 8½.
0-486-27673-2

PAINTING MATERIALS: A SHORT ENCYCLOPEDIA, R. J. Gettens and G. L. Stout. Thorough, exhaustive coverage of materials, media, and tools of painting through the ages based on historical studies. 34 illustrations. 333pp. 5⅜ x 8½. 0-486-21597-0

LIFE DRAWING IN CHARCOAL, Douglas R. Graves. Innovative method of drawing by tonal masses. Step-by-step demonstrations and more than 200 illustrations cover foreshortening, drawing the face, and other aspects. 176pp. 8¼ x 11. 0-486-28268-6

A GUIDE TO PICTORIAL PERSPECTIVE, Benjamin R. Green. Meeting the challenge of realistic drawing involves the application of science to an individual design sense. Here is a clear, jargon-free primer on recreating objects from nature by using perspective techniques. Its straightforward approach teaches artists and students at all levels how to visually rationalize the differences between form and appearance. 64pp. 5⅜ x 8½.
0-486-44404-X

CREATING WELDED SCULPTURE, Nathan Cabot Hale. Profusely illustrated guide, newly revised, offers detailed coverage of basic tools and techniques of welded sculpture. Abstract shapes, modeling solid figures, arc welding, large-scale welding, and more. 196 illustrations. 208pp. 8⅜ x 11¼. 0-486-28135-3

HAWTHORNE ON PAINTING, Charles W. Hawthorne. Collected from notes taken by students at famous Cape Cod School; hundreds of direct, personal, and pertinent observations on technique, painting ideas, self criticism, etc. A mine of ideas, aperçus, and suggestions for artists. 91pp. 5⅜ x 8½.
0-486-20653-X

HAWTHORNE ON PAINTING, GEOMETRIC PATTERNS AND HOW TO CREATE THEM, Clarence P. Hornung. Rich collection of 164 permission-free geometric patterns includes guidelines for creating hundreds of eye-catching graphics. Each basic design is followed by three dazzling variations. 48pp. 8¼ x 11. 0-486-41733-6

Art Instruction

THE ART OF ANIMAL DRAWING: CONSTRUCTION, ACTION ANALYSIS, CARICATURE, Ken Hultgren. Former Disney animator offers expert advice–with more than 700 illustrations on drawing animals realistically and as caricatures. Line, brush technique, mood, action, and more. Dogs, cats, deer, foxes, rabbits, etc. ix+134pp. 8⅜ x 11. 0-486-27426-8

WAYS WITH WATERCOLOR, Ted Kautzky. Simple, direct language discusses color pigments, paper, and other supplies; washes, strokes, and the use of accessories for special effects. Valuable instructions on composition. 125 illustrations, including 37 color plates. 144pp. 8⅜ x 11. 0-486-43954-2

MODELLING AND SCULPTING THE HUMAN FIGURE, Edouard Lanteri. Covers modelling from casts, live models; measurements; frameworks; scale of proportions; compositions; reliefs, drapery, medals, etc. 107 full-page photographic plates. 27 other photographs. 175 drawings and diagrams. 480pp. 5³/₈ x 8. 0-486-25006-7

THE PAINTER'S METHODS AND MATERIALS, A. P. Laurie. Foremost authority on techniques and materials: permanency, pigments, tempera, varnishes, etc. Modern procedures plus insights into classical techniques of the masters. 64 illustrations. 250pp. 5⅜ x 8½. 0-486-21868-6

ETCHING, ENGRAVING AND OTHER INTAGLIO PRINTMAKING TECHNIQUES, Ruth Leaf. Comprehensive handbook covers materials and equipment, tools, printing papers, presses, and other essentials. Detailed instructions for etching, engraving, drypointing, collagraphs, tuilegraphs, and the Blake transfer method. Profusely illustrated. 232pp. 8⅜ x 11¼. 0-486-24721-X

THE ANATOMY AND ACTION OF THE HORSE, Lowes D. Luard. Easy-to-read text explains the horse as a machine designed for movement, with meticulously rendered sketches of the entire animal supplementing diagrams and color illustrations of the horse's anatomy. 62 b/w illustrations. xiv+146pp. plus 24-page full-color insert. 6½ x 9¼. 0-486-42980-6

LIGHT AND SHADE: A CLASSIC APPROACH TO THREE-DIMENSIONAL DRAWING, Mary P. Merrifield. Handy reference clearly demonstrates principles of light and shade by revealing effects of common daylight, sunshine, and candle or artificial light on geometrical solids. 13 plates. 64pp. 5⅜ x 8½. 0-486-44143-1

THE HUMAN FIGURE IN MOTION, Eadweard Muybridge. The 4,789 photographs in this definitive selection show human figures–models almost all undraped–engaged in more than 160 different types of action: running, climbing stairs, tumbling, dressing, dancing, etc. 390pp. 7⅞ x 10⅝. 0-486-20204-6

ANIMAL DRAWING AND ANATOMY, Edwin Noble. Written and illustrated by a distinguished artist and art instructor, this volume features valuable insights into reproducing accurate images of horses, cows, dogs, sheep, birds, and wild animals. Advice on depicting musculature, hair, feathers, and other obvious physical features, plus action, pose, proportions, and character. 233 drawings. 128pp. 5⅜ x 8½. 0-486-42312-3

PERSPECTIVE MADE EASY, Ernest Norling. Perspective is easy; yet surprisingly few artists know the simple rules that make it so. Remedy that situation with this simple, step-by-step book, the first devoted entirely to the topic. Horizon, vanishing point, shade and shadow, and much more. 256 illustrations. 224pp. 5⅜ x 8½. 0-486-40473-0

PAINTING AND DRAWING CHILDREN, John Norton. Great children's portraitist covers every aspect of the subject, from getting to know the child to fees and public relations. Full-color layouts show step-by-step evolution of four beautiful portraits. 59 b/w and 40 color illustrations. 176pp. 8⅛ x 11. 0-486-41803-0

DRAWING OUTDOORS, Henry C. Pitz. How to draw every major outdoor subject–land, greenery, skies, buildings, people, cities, and more–in all the major drawing media. Many examples from the masters. More than 100 illustrations. 144pp. 8⅛ x 11. 0-486-28679-7

COMPOSITION IN ART, Henry Rankin Poore. Learn principles of composition, classical and modern, through analysis of works from Middle Ages to present. 148 illustrations, 9 in color. 104pp. 8⅛ x 11. 0-486-23358-8

THE MATERIALS AND METHODS OF SCULPTURE, Jack C. Rich. Exhaustive, profusely illustrated guide to technical aspects of sculpting in stone, metal, wood, and other materials. Tools, techniques, modelling, casting, firing, and much more. 281 illustrations. 512pp. 6½ x 9¼. 0-486-25742-8

HENSCHE ON PAINTING, John W. Robichaux. Basic painting philosophy and methodology of a great teacher, as expounded in his famous classes and workshops on Cape Cod. 7 illustrations in color on covers. 80pp. 5⅜ x 8½. 0-486-43728-0

THE ELEMENTS OF DRAWING, John Ruskin. Timeless classic by one of the greatest art critics of all time begins with bare fundamentals and offers brilliant philosophical advice. Many practical exercises. 48 illustrations. 228pp. 5⅜ x 8½. 0-486-22730-8

THE ENJOYMENT AND USE OF COLOR, Walter Sargent. Color relationships, values, intensities; complementary colors, illumination, and similar topics. Color in nature and art. 7 color plates. 29 illustrations. 274pp. 5⅜ x 8½. 0-486-20944-X

DRAWING THE LIVING FIGURE, Joseph Sheppard. Innovative approach to artistic anatomy focuses on specifics of surface anatomy, rather than muscles and bones. Over 170 drawings of live models in front, back, and side views, and in widely varying poses. Accompanying diagrams. 177 illustrations. 144pp. 8⅜ x 11¼. 0-486-26723-7

JOHN SLOAN ON DRAWING AND PAINTING, John Sloan. This illustrated, practical record of talks and instructional advice by a member of the "Ashcan School" of American painting discusses line, tone, texture, light and shade, composition, design, space, perspective, and related issues. Wealth of helpful suggestions and exercises. 252pp. 5⅜ x 8½. 0-486-40947-3

SCULPTURE: PRINCIPLES AND PRACTICE, Louis Slobodkin. Step-by-step approach to clay, plaster, metals, and stone; classical and modern. 253 drawings, photos. 255pp. 8⅛ x 11. 0-486-22960-2

THE PRACTICE AND SCIENCE OF DRAWING, Harold Speed. Classic approach to the dynamics of drawing by brilliant teacher with insights and practical advice on line drawing, mass drawing, visual memory, materials, and much more. 84 plates and diagrams. 296pp. 5⅜ x 8½. 0-486-22870-3

THE PRACTICE OF TEMPERA PAINTING, Daniel V. Thompson, Jr. Historical background, step-by-step instruction, materials, permanence. Lucid, careful exposition of all aspects of authentic technique. 85 illustrations. 141pp. 5⅜ x 8½. 0-486-20343-3

A HANDBOOK OF ANATOMY FOR ART STUDENTS, Arthur Thomson. Thorough coverage of skeletal structure, muscles, heads, etc. Text supplemented by anatomical drawings, diagrams, and photos of undraped figures. 211 figures, 40 drawings, 86 photos. 459pp. 5⅜ x 8½. 0-486-21163-0

THE WATSON DRAWING BOOK, Ernest W. Watson and Aldren A. Watson. Authoritative, stimulating book brims with information on drawing techniques, media, and artistic examples. Technical information and tips on perspective, measure and form analysis, rendering light, shade, and shadow, portrait drawing, figure sketching, and outdoor sketching. 160pp. 8¼ x 10¼. 0-486-42606-8

COMPLETE GUIDE TO WATERCOLOR PAINTING, Edgar A. Whitney. Brilliant guide by renowned artist tells all, from basics to creating masterful landscapes, portraits, and figures. Full-color sections follow evolution of seven of the author's own watercolors. More than 100 illustrations, including 37 in color. 176pp. 8¼ x 10¾. 0-486-41742-5

CALLIGRAPHY IN TEN EASY LESSONS, Eleanor Winters and Laurie E. Lico. Beginners can get started on the basic Italic hand with this practical guide. Detailed discussions cover spacing, connecting letters; forming words and sentences; drawing "swash" capitals; and more, plus applications–addressing envelopes, making stationery, and transcribing special texts. Numerous b/w illustrations. 112pp. 8⅜ x 11. 0-486-41804-9

PENCIL DRAWING, Michael Woods. Complete first course covers basic techniques, line work, shading, tone, perspective, composition, even fixing, mounting, and framing. Engaging, easy-to-follow text enhanced with 155 carefully prepared illustrations. 118pp. 6¾ x 9½. 0-486-25886-6

Dover Books on Art & Art History

DE RE METALLICA, Georgius Agricola. One of the most important scientific classics of all time, this 1556 work on mining was the first based on field research and observation and the methods of modern science. 289 authentic Renaissance woodcuts. Translated by Herbert Hoover. Reprint of English (1912) edition. 672pp. 6¾ x 10¾. 0-486-60006-8

THE UNIVERSAL PENMAN, George Bickham. Famous treasury of English roundhand calligraphy of 1740. Alphabets, decorated pages, scrolls, frames, cupids, and similar material. 212pp. 9 x 13¾. 0-486-20616-5

THE ART OF BOTANICAL ILLUSTRATION: AN ILLUSTRATED HISTORY, Wilfrid Blunt. Surveys the evolution of botanical illustration from the crude scratchings of paleolithic man down to the highly scientific work of 20th-century illustrators. With 186 magnificent examples, more than 30 in full color. "A classic"—*The Sunday Times* (London). 372pp. 5⅜ x 8¼. 0-486-27265-6

IDOLS BEHIND ALTARS: MODERN MEXICAN ART AND ITS CULTURAL ROOTS, Anita Brenner. Critical study ranges from pre-Columbian times through the 20th century to explore Mexico's intrinsic association between art and religion; the role of iconography in Mexican art; and the return to native values. Unabridged reprint of the classic 1929 edition. 118 b/w illustrations. 432pp. 5⅜ x 8½. 0-486-42303-4

THE BOOK OF KELLS, Blanche Cirker (ed.). 32 full-color, full-page plates from the greatest illuminated manuscript of the Middle Ages; painstakingly reproduced from rare facsimile edition. Publisher's Note. Captions. 32pp. 9⅜ x 12¼. 0-486-24345-1

CHRISTIAN AND ORIENTAL PHILOSOPHY OF ART, Ananda K. Coomaraswamy. Nine essays by philosopher-art-historian on symbolism, traditional culture, folk art, ideal portraiture, etc. 146pp. 5⅜ x 8½. 0-486-20378-6

THE SECRET LIFE OF SALVADOR DALÍ, Salvador Dalí. One of the most readable autobiographies ever! Superbly illustrated with more than 80 photos of Dalí and his works, and scores of Dalí drawings and sketches. "It is impossible not to admire this painter as writer . . . (Dalí) communicates the snobbishness, self-adoration, comedy, seriousness, fanaticism, in short the concept of life and the total picture of himself he sets out to portray."—*Books.* 432pp. 6½ x 9¼. (Available in U.S. only) 0-486-27454-3

LEONARDO ON ART AND THE ARTIST, Leonardo da Vinci (André Chastel, ed.). Systematic grouping of passages of Leonardo's writings concerning painting, with focus on problems of interpretation. More than an anthology, it offers a reconstruction of the underlying meaning of Leonardo's words. Introduction, notes, and bibliographic and reference materials. More than 125 b/w illustrations. 288pp. 9¼ x 7⅝. 0-486-42166-X

LEONARDO ON THE HUMAN BODY, Leonardo da Vinci. More than 1,200 of Leonardo's anatomical drawings on 215 plates. Leonardo's text, which accompanies the drawings, has been translated into English. 506pp. 8⅜ x 11¼. 0-486-24483-0

A TREATISE ON PAINTING, Leonardo da Vinci. The great Renaissance artist's practical advice on drawing and painting techniques covers anatomy, perspective, composition, light and shadow, and color. A classic of art instruction, it features 48 drawings by Nicholas Poussin and Leon Battista Alberti. vii+182pp. 5⅜ x 8½. 0-486-44155-5

THE BOOK BEFORE PRINTING: ANCIENT, MEDIEVAL AND ORIENTAL, David Diringer. Rich authoritative study of the book before Gutenberg. Nearly 200 photographic facsimiles of priceless documents. 604pp. 5⅜ x 8½. 0-486-24243-9

GAUGUIN'S INTIMATE JOURNALS, Paul Gauguin. Revealing documents, reprinted from rare, limited edition, throw much light on the painter's inner life, his tumultuous relationship with van Gogh, evaluations of Degas, Monet, and other artists; hatred of hypocrisy and sham, life in the Marquesas Islands, and much more. 27 full-page illustrations by Gauguin. Preface by Emil Gauguin. 160pp. 6½ x 9¼. 0-486-29441-2

THE GEOMETRY OF ART AND LIFE, Matila Ghyka. Revealing discussion ranging from Plato to modern architecture. 80 plates and 64 figures, including paintings, flowers, shells, etc. 174pp. 5⅜ x 8½. 0-486-23542-4

A MANUAL OF HISTORIC ORNAMENT, Richard Glazier. Hundreds of detailed illustrations depict painted pilasters from Pompeii, early Gothic stone carvings, a detail from a stained glass window in Canterbury Cathedral, and much more. Unabridged reprint of the 6th edition (1948) of *A Manual of Historic Ornament,* originally published in 1899 by B. T. Batsford, Ltd., London. Over 700 b/w illustrations. 16 plates of photographs. x+230pp. 6¼ x 9¼. 0-486-42148-1

THE DISASTERS OF WAR, Francisco Goya. This powerful graphic indictment of war's horrors–inspired by the Peninsular War and the following famine–comprises 80 prints and includes veiled attacks on various people, the Church, and the State. Captions reprinted with English translations. 97pp. 9⅜ x 8¼. 0-486-21872-4

GREAT DRAWINGS OF NUDES, Carol Belanger Grafton (ed.). An impressive sampling of life drawings by 45 of the art world's greatest masters displays the styles of figure drawing across five centuries, from Dürer and Michelangelo to Modigliani and Derain. Featured artists include Raphael, Rubens, van Dyck, Hogarth, Constable, Ingres, Gauguin, Matisse, Rodin, and others. Captions. 48pp. 8¼ x 11. 0-486-42766-8

GREAT SELF-PORTRAITS, Carol Belanger Grafton (ed.). Unique volume of 45 splendid self-portraits encompasses pen, ink, and charcoal renderings as well as etchings and engravings. Subjects range from such 15th-century artists as da Vinci and Dürer to a host of 19th-century masters: Whistler, Rodin, van Gogh, Beardsley, and many more–Rembrandt, Rubens, Goya, Blake, Pissarro, and numerous others. 45 b/w illustrations. 48pp. 8¼ x 11. 0-486-42168-6

HAWTHORNE ON PAINTING, Charles W. Hawthorne. Collected from notes taken by students at famous Cape Cod School; hundreds of direct, personal aperçus, ideas, suggestions. 91pp. 5⅜ x 8½. 0-486-20653-X

MODERN MEXICAN PAINTERS, MacKinley Helm. Definitive introduction to art and artists of Mexico during great artistic movements of '20s and '30s. Discussion of Rivera, Orozco, Siqueiros, Galvan, Cantú, Meza, and many others. 95 illustrations. 228pp. 6½ x 9¼. 0-486-26028-3

MODERN ARTISTS ON ART, SECOND ENLARGED EDITION, Robert L. Herbert (ed.). Sixteen of the twentieth century's leading artistic innovators talk forcefully about their work–from Albert Gleizes and Jean Metzinger's 1912 presentation of Cubist theory to Henry Moore's comments, three decades later, on sculpture and primitive art. Four essays by Kurt Schwitters, Max Ernst, El Lissitzky, and Fernand Léger. 192pp. 5⅜ x 8½. 0-486-41191-5

A HISTORY OF ENGRAVING AND ETCHING, Arthur M. Hind. British Museum Keeper of Prints offers complete history, from 15th century to 1914: accomplishments, influences, and artistic merit. 111 illustrations. 505pp. 5⅜ x 8½. 0-486-20954-7

ART AND GEOMETRY, William M. Ivins. Stimulating, controversial study of interrelations of art and mathematics, Greek disservice and contribution. Renaissance perspective, Dürer and math, etc. 123pp. 5⅜ x 8½. 0-486-20941-5

A TREASURY OF BOOKPLATES FROM THE RENAISSANCE TO THE PRESENT, Fridolf Johnson (ed.). 759 of the finest specimens including Dürer, Beardsley, Kent, and others, from many traditions, selected by the former editor of *American Artist.* 151pp. 8⅜ x 11¼. 0-486-23485-1

CONCERNING THE SPIRITUAL IN ART, Wassily Kandinsky. Pioneering work by father of abstract art. Thoughts on color theory and nature of art. Analysis of earlier masters. 12 illustrations. 80pp. of text. 5⅜ x 8½. 0-486-23411-8

POINT AND LINE TO PLANE, Wassily Kandinsky. Seminal exposition of role of line, point, and other elements of non-objective painting. Essential to understanding 20th-century art. 127 illustrations. 192pp. 6½ x 9¼. 0-486-23808-3

LANGUAGE OF VISION, Gyorgy Kepes. Noted painter, designer, and theoretician analyzes effect of visual language on human consciousness: perception of line and form, perspective, much more. Over 300 photos, drawings, and illustrations. 224pp. 8⅜ x 11¼. 0-486-28650-9

Dover Books on Art and Art History

GOTHICK ARCHITECTURE: A REPRINT OF THE ORIGINAL 1742 TREATISE, **Batty Langley and Thomas Langley.** The architectural designs of Batty Langley greatly influenced England's Gothic Revival movement in the second half of the eighteenth century. This volume, which completely reproduces the author's most famous and influential work (beautifully engraved by his brother Thomas), displays columns, entablatures, windows, mantels, pavilions, and a host of other architectural features. This collection of permission-free illustrations will be welcomed by students and aficionados of eighteenth-century architecture, as well as designers and artists in search of period elegance. 80pp. 9 x 12. 0-486-42614-9

THE ART-MAKERS, **Russell Lynes.** Eakins, Hunt, French, Morse, Trumbull, and others, and their heroic struggle to make art respectable in 19th-century America. 211 illustrations. 526pp. 6⅜ x 9. 0-486-24239-0

RELIGIOUS ART IN FRANCE OF THE THIRTEENTH CENTURY, **Emile Mâle.** Classic by noted art historian focuses on French cathedrals of the 13th century as apotheosis of medieval style. Iconography, bestiaries, illustrated calendars, gospels, secular history, and many other aspects. 190 b/w illustrations. 442pp. 5⅜ x 8½. 0-486-41061-7

VINCENT VAN GOGH: A BIOGRAPHY, **Julius Meier-Graefe.** Utterly engrossing account of legendary artist's entire life from birth to his suicide. Essential readings for anyone interested in van Gogh's life and art. 160pp. 5⅜ x 8½. 0-486-25253-1

THE NEW VISION: FUNDAMENTALS OF BAUHAUS DESIGN, PAINTING, SCULPTURE, AND ARCHITECTURE, **László Moholy-Nagy.** Valuable introduction to aims and methods of the Bauhaus movement. Generously illustrated with examples of students' experiments and contemporary achievements. 257 illustrations. 240pp. 8¼ x 10⅞. 0-486-43693-4

THE GOLDEN AGE OF THE STEAM LOCOMOTIVE: WITH OVER 250 CLASSIC ILLUSTRATIONS, **J. G. Pangborn.** Long a collector's item, this book was originally conceived as a record of the Baltimore and Ohio Railroad's exhibit at the world's Columbian exposition of 1893 in Chicago. More than 250 illustrations showcase the locomotives and cars that existed from 1765 to 1893, among them, the *John Hancock, Londoner, Mud Digger, Old Ironsides, Robert Fulton, Tom Thumb,* and others. Unabridged reprint of the classic 1894 edition. 251 black-and-white illustrations. 176pp. 9⅜ x 12¼. 0-486-42824-9

PAINTERS OF THE ASHCAN SCHOOL, **Bennard B. Perlman.** Lively, beautifully illustrated study of 8 artists who brought a compelling new realism to American painting from 1870 to 1913. Henri, Glackens, Sloan, Luks, 4 more. 142 b/w illustrations. Bibliography. Introduction. 224pp. 9⅜ x 11¼. 0-486-25747-9

ROBERT HENRI: HIS LIFE AND ART, **Bennard B. Perlman.** A compelling new biography of the founder of the "Ashcan School," tracing Henri's life and art from his boyhood to his rise as an influential painter, teacher, and activist in the politics of art, and astutely appraising his pivotal role in American art. 79 illustrations, including 21 full-color and 9 black-and-white photos. Index. 208pp. 8⅜ x 11¼. 0-486-26722-9

COMPOSITION IN ART, **Henry Rankin Poore.** Learn principles of composition, classical and modern, through analysis of works from Middle Ages to present. 148 illustrations, 9 in color. 104pp. 8⅛ x 11. 0-486-23358-8

PAINTERS ON PAINTING, **Eric Protter.** Fascinating insights as da Vinci, Michelangelo, Rubens, Rembrandt, Hogarth, Manet, Degas, Cézanne, van Gogh, Matisse, Pollock, Johns, and many other artists comment on their artistic techniques, objectives, other artists, and more. 68 illustrations. 312pp. 5⅜ x 8½. 0-486-29941-4

SHAKESPEARE'S A MIDSUMMER NIGHT'S DREAM, illustrated by **Arthur Rackham.** Shakespeare's romantic comedy takes on a new and vivid life with these brilliant images by of one of the twentieth century's leading illustrators. This faithful reprint offers a quality of printing and sharpness of reproduction that rivals the limited and first editions of 1908. Includes the complete text of the play, along with 40 full-color and numerous black-and-white illustrations. 176pp. 8⅜ x 11. 0-486-42833-8

THE ILLUSTRATOR AND THE BOOK IN ENGLAND FROM 1790 TO 1914, **Gordon N. Ray.** Combining essays, bibliographical descriptions, and 295 illustrations, this book by one of America's leading literary scholars and book antiquarians definitively chronicles a golden era in the art of the illustrated book. Artists range from Blake, Turner, Rowlandson, and Morris to Caldecott, Greenaway, Beardsley, and Rackham. 384pp. 8⅜ x 11¼. 0-486-26955-8

RHYTHMIC FORM IN ART, **Irma A. Richter.** In this captivating study, an influential scholar-artist offers timeless advice on shape, form, and composition for artists in any medium. Irma Richter illuminates the connections between art and science by surveying works of art from classical antiquity through the Modernist era. 38 figures. 34 plates. 192pp. 8⅜ x 11. 0-486-44379-5

THE NOTEBOOKS OF LEONARDO DA VINCI, **Jean Paul Richter (ed.).** These 1,566 extracts reveal the full range of Leonardo's versatile genius. Volume I is devoted to various aspects of art: structure of the eye and vision, perspective, science of light and shade, color theory, more. Volume II shows the wide range of Leonardo's secondary interests: geography, warfare, zoology, medicine, astronomy, and other topics. Dual Italian-English texts, with a total of 122 plates and hundreds of additional drawings. 7⅞ x 10¾.

Vol. I: 64 plates, xxix+367pp. 0-486-22572-0
Vol. II: 58 plates, xv+499pp. 0-486-22573-9

RODIN ON ART AND ARTISTS, **Auguste Rodin.** Wide-ranging comments on meaning of art; great artists; relation of sculpture to poetry, painting, music, philosophy of life, and more. 76 illustrations of Rodin's sculpture, drawings, and prints. 119pp. 8⅜ x 11¼. 0-486-24487-3

THE SEARCH FOR FORM IN ART AND ARCHITECTURE, **Eliel Saarinen.** Important philosophical volume by foremost architectural conceptualist emphasizes design on an organic level; interrelated study of all arts. 377pp. 5⅜ x 8½. 0-486-24907-7

THE SENSE OF BEAUTY, **George Santayana.** Masterfully written discussion of nature of beauty, form, and expression; art, literature, and social sciences all involved. 168pp. 5⅜ x 8½. 0-486-20238-0

PICASSO, **Gertrude Stein.** Intimate, revealing memoir of Picasso as founder of Cubism, intimate of Apollinaire, Braque, and others; creative spirit driven to convey reality of twentieth century. Highly readable. 61 black-and-white illustrations. 128pp. 5⅜ x 8½. 0-486-24715-5

ON DIVERS ARTS, **Theophilus (translated by John G. Hawthorne and C. S. Smith).** Earliest (12th century) treatise on arts written by practicing artist. Pigments, glass blowing, stained glass, gold and silver work, and more. Authoritative edition of a medieval classic. 34 illustrations. 216pp. 6½ x 9¼. 0-486-23784-2

VAN GOGH ON ART AND ARTISTS: LETTERS TO EMILE BERNARD, **Vincent van Gogh.** 23 missives—written during the years 1887 to 1889—radiate their author's impulsiveness, intensity, and mysticism. The letters are complemented by reproductions of van Gogh's major paintings. 32 full-page, b/w illustrations. xii+196pp. 8⅜ x 11. 0-486-42727-7

VASARI ON TECHNIQUE, **Georgio Vasari.** Sixteenth-century painter and historian on technical secrets of the day: gilding, stained glass, casting, painter's materials, etc. 29 illustrations. 328pp. 5⅜ x 8½. 0-486-20717-X

RECOLLECTIONS OF A PICTURE DEALER, **Ambroise Vollard.** Art merchant and bon vivant Ambroise Vollard (1867–1939) recounts captivating anecdotes from his professional and social life: selling the works of Cézanne; partying with Renoir, Forain, Degas, and Rodin; the studios and personalities of Manet, Matisse, Picasso, and Rousseau; and encounters with Gertrude Stein, Zola, and other noteworthies. 33 illustrations. 384pp. 5⅜ x 8½. 0-486-42852-4

ETCHINGS OF JAMES MCNEILL WHISTLER, **James McNeill Whistler (selected and edited by Maria Naylor).** The best of the artist's work in this genre: 149 outstanding etchings and drypoint, most in original size, all reproduced with exceptional quality. Popular individual prints include "Portrait of Whistler," "Old Battersea Bridge," "Nocturne," plus complete French set, Thames set, and two Venice sets. Introduction and an explanatory note for each print. 149 b/w illustrations. xviii+157pp. 9⅜ x 12¼. 0-486-42481-2

THE GENTLE ART OF MAKING ENEMIES, **James McNeill Whistler.** Great wit deflates Wilde, Ruskin, and Swinburne; belabors inane critics; also states Impressionist aesthetics. 334pp. 5⅜ x 7⅞. 0-486-21875-9

PRINCIPLES OF ART HISTORY, **Heinrich Wölfflin.** Seminal modern study explains ideas beyond superficial changes. Analyzes more than 150 works by masters. 121 illustrations. 253pp. 6⅛ x 9¼. 0-486-20276-3

Medieval Art through Eighteenth-Century Art

GRAPHIC WORLDS OF PETER BRUEGEL THE ELDER, Peter Bruegel. 63 engravings and a woodcut made from the drawings of the 16th-century Flemish master: landscapes, seascapes, stately ships, drolleries, whimsical allegories, scenes from the Gospels, and much more. Stimulating commentaries by H. Arthur Klein on individual prints, bits of biography on etcher or engraver, and comparisons with Bruegel's original designs. 176pp. 9⅜ x 12¼. 0-486-21132-0

VIEWS OF VENICE BY CANALETTO, Antonio Canaletto (engraved by Antonio Visentini). Unparalleled visual statement from early 18th century includes 14 scenes down the Grand Canal away from and returning to the Rialto Bridge, 12 magnificent view s of the inimitable *campi,* and more. Extraordinarily handsome, large-format edition. Text by J. Links. 50 illustrations. 90pp. 13¾ x 10. 0-486-22705-7

THE CRAFTSMAN'S HANDBOOK, Cennino Cennini. This fifteenth century handbook reveals secrets and techniques of the masters in drawing, oil painting, frescoes, panel painting, gilding, casting, and more. 142pp. 6⅛ x 9¼. 0-486-20054-X

THE BOOK OF KELLS, Blanche Cirker (ed.). Thirty-two full-color, full-page plates from the greatest illuminated manuscript of the Middle Ages; painstakingly reproduced from rare facsimile edition. Publisher's Note. Captions. 32pp. 9⅜ x 12¼. 0-486-24345-1

THE COMPLETE ENGRAVINGS, ETCHINGS AND DRYPOINTS OF ALBRECHT DÜRER, Albrecht Dürer. This splendid collection reproduces all 105 of Dürer's works in these media, including such well-known masterpieces as *Knight, Death and Devil, Melencolia I,* and *Adam and Eve,* plus portraits of such contemporaries as Erasmus and Frederick the Wise; popular and religious works; peasant scenes, and the portentous works: *The Four Witches, Sol Justitiae,* and *The Monstrous Sow of Landser.* 120 plates. 235pp. 8⅜ x 11¼. 0-486-22851-7

THE HUMAN FIGURE, Albrecht Dürer. This incredible collection contains drawings in which Dürer experimented with many methods: the "anthropometric system," learned from Leonardo; the "exempeda" method, known to most as the man inscribed in a circle; the human figure in motion: and much more. Some of the life studies rank among the finest ever done. 170 plates. 355pp. 8⅜ x 11¼. 0-486-21042-1

MEDIEVAL WOODCUT ILLUSTRATIONS, Carol Belanger Grafton (ed.). Selections from a 1493 history of the world features magnificent woodcuts of 91 locales, plus 143 illustrations of figures and decorative objects. Comparable to the Gutenberg Bible in terms of craftsmanship; designed by Pleydenwuff and Wolgemut. Permission-free. 194 b/w illustrations. 80pp. 8⅜ x 11. 0-486-40458-7

ENGRAVINGS OF HOGARTH, William Hogarth. Collection of 101 robust engravings reveals the life of the drawing rooms, inns, and alleyways of 18th-century England through the eyes of a great satirist. Includes all the major series: *Rake's Progress, Harlot's Progress,* Illustrations for *Hudibras, Before and After, Beer Street,* and *Gin Lane,* plus 96 more with commentary by Sean Shesgreen. xxxiii+205pp. 11 x 13¾. 0-486-22479-1

THE DANCE OF DEATH, Hans Holbein the Younger. Most celebrated of Holbein's works. Unabridged reprint of the original 1538 masterpiece and one of the great graphic works of the era. Forty-one striking woodcuts capture the motif *Memento mori*–"Remember, you will die." Includes translations of all quotes and verses. 146pp. 5⅜ x 8½. 0-486-22804-5

THE MEDIEVAL SKETCHBOOK OF VILLARD DE HONNECOURT, Villard de Honnecourt. Little may be known about Villard de Honnecourt, but thanks to his immortal *Sketchbook,* reliable and contemporaneous graphic observations exist about everyday life in 13th-century France. Contained in this volume are the entire contents of Honnecourt's portfolio, complete with authoritative translations of the artist's words, annotation, and editor's commentary. 160pp. 8⅜ x 11. 0-486-44358-2

THE COMPLETE WOODCUTS OF ALBRECHT DÜRER, Dr. W. Kurth (ed.). Superb collection of 346 extant woodcuts: the celebrated series on the *Life of Virgin, the Apocalypse of St. John, the Great Passion, St. Jerome in His Study, Samson Fighting the Lion, The Fall of Icarus, The Rhinoceros, the Triumphal Arch, Saints and Biblical Scenes,* and many others, including much little-known material. 285pp. 8½ x 12¼. 0-486-21097-9

RELIGIOUS ART IN FRANCE OF THE THIRTEENTH CENTURY, Emile Mâle. This classic by a noted art historian focuses on French cathedrals of the 13th century as the apotheosis of the medieval style. Topics include iconography, bestiaries, illustrated calendars, the gospels, secular history, and many other aspects. 190 b/w illustrations. 442pp. 5⅜ x 8½. 0-486-41061-7

THE MIND OF LEONARDO DA VINCI, Edward McCurdy. More than just a biography, this classic study by a distinguished historian draws upon Leonardo's extensive writings to offer numerous demonstrations of the Renaissance master's achievements, not only in sculpture and painting, but also in music, engineering, and even experimental aviation. iv+364pp. 5⅜ x 8½. 0-486-44142-3

GREAT SCENES FROM THE BIBLE: 230 Magnificent 17th Century Engravings, Matthaeus Merian (the Elder). Remarkably detailed illustrations depict Adam and Eve Driven Out of the Garden of Eden, The Flood, David Slaying Goliath, Christ in the Manger, The Raising of Lazarus, The Crucifixion, and many other scenes. A wonderful pictorial dimension to age-old stories. All plates from the classic 1625 edition. 128pp. 9 x 12. 0-486-42043-4

THE NOTEBOOKS OF LEONARDO DA VINCI, compiled and edited by Jean Paul Richter. These 1,566 extracts reveal the full range of Leonardo's versatile genius: his writings on painting, sculpture, architecture, anatomy, mining, inventions, and music. The first volume is devoted to various aspects of art: structure of the eye and vision, perspective, science of light and shade, color theory, and more. The second volume shows the wide range of Leonardo's secondary interests: geography, warfare, zoology, medicine, astronomy, and other topics. Dual Italian-English texts, with 186 plates and more than 500 additional drawings faithfully reproduced. Total of 913pp. 7⅞ x 10¾. Vol. I: 0-486-22572-0; Vol. II: 0-486-22573-9

ON DIVERS ARTS, Theophilus (translated by John G. Hawthorne and C. S. Smith). Twelfth-century treatise on arts written by a practicing artist. Pigments, glass blowing, stained glass, gold and silver work, and more. Authoritative edition of a medieval classic. 34 illustrations. 216pp. 6½ x 9¼. 0-486-23784-2

THE COMPLETE ETCHINGS OF REMBRANDT: REPRODUCED IN ORIGINAL SIZE, Rembrandt van Rijn. One of the greatest figures in Western Art, Rembrandt van Rijn (1606–1669) brought etching to a state of unsurpassed perfection. This edition includes more than 300 works–portraits, landscapes, biblical scenes, allegorical and mythological pictures, and more–reproduced in full size directly from a rare collection of etchings famed for its pristine condition, rich contrasts, and brilliant printing. With detailed captions, chronology of Rembrandt's life and etchings, discussion of the technique of etching in this time, and a bibliography. 224pp. 9⅜ x 12¼. 0-486-28181-7

DRAWINGS OF REMBRANDT, Seymour Slive (ed.) Updated Lippmann, Hofstede de Groot edition, with definitive scholarly apparatus. Many drawings are preliminary sketches for great paintings and sketchings. Others are self-portraits, beggars, children at play, biblical sketches, landscapes, nudes, Oriental figures, birds, domestic animals, episodes from mythology, classical studies, and more. Also, a selection of work by pupils and followers. Total of 630pp. 9⅜ x 12¼. Vol. I: 0-486-21485-0; Vol. II: 0-486-21486-9

THE MATERIALS AND TECHNIQUES OF MEDIEVAL PAINTING, Daniel V. Thompson. Sums up 20th-century knowledge: paints, binders, metals, and surface preparation. 239pp. 5⅜ x 8½. 0-486-20327-1

DRAWINGS OF ALBRECHT DÜRER, Heinrich Wölfflin (ed.). 81 plates show development from youth to full style: *Dürer's Wife Agnes, Idealistic Male and Female Figures* (Adam and Eve), *The Lamentation,* and many others. The editor not only introduces the drawings with an erudite essay, but also supplies captions for each, telling about the circumstances of the work, its relation to other works, and significant features. 173pp. 8⅛ x 11. 0-486-22352-3

Nineteenth-Century Art

GREAT DRAWINGS AND ILLUSTRATIONS FROM PUNCH, 1841–1901, Stanley Appelbaum and Richard Kelly (eds.). Golden years of British illustration. 192 drawings by 25 artists: Phiz, Leech, Tenniel, du Maurier, Sambourne. 144pp. 9 x 12. 0-486-24110-6

BEST WORKS OF AUBREY BEARDSLEY, Aubrey Beardsley. Rich selection of 170 boldly executed black-and-white illustrations ranging from illustrations for Laclos' *Les Liaisons Dangereuses* and Balzac's *La Comédie Humaine* to magazine cover designs, book plates, title-page ornaments for books, silhouettes, and delightful mini-portraits of major composers. 160pp. 8⅜ x 11. 0-486-26273-1

THE RAPE OF THE LOCK, Aubrey Beardsley and Alexander Pope. Reproduction of "ideal" 1896 edition in which text, typography, and illustration complement each other. 10 great illustrations capture the mock-heroic, delicate fancy of Pope's poem. 47pp. 8¼ x 11. 0-486-21963-1

SALOME, Aubrey Beardsley and Oscar Wilde. Lord Alfred Douglas' translation of Wilde's great play (originally written in French,) with all 20 well-known Beardsley illustrations including suppressed plates. Introduction by Robert Ross. xxii+69pp. 8⅛ x 11. 0-486-21830-9

DRAWINGS OF WILLIAM BLAKE, William Blake. Fine reproductions show the range of Blake's artistic genius: drawings for *The Book of Job, The Divine Comedy, Paradise Lost,* an edition of Shakespeare's plays, grotesques and visionary heads, mythological figures, and other drawings. Selection, introduction, and commentary by Sir Geoffrey Keynes. 178pp. 8⅛ x 11.

0-486-22303-5

SONGS OF INNOCENCE, William Blake. The first and most popular of Blake's famous "Illuminated Books" in a facsimile edition. 31 illustrations, text of each poem. 64pp. 5¼ x 7. 0-486-22764-2

A CÉZANNE SKETCHBOOK: FIGURES, PORTRAITS, LANDSCAPES AND STILL LIFES, Paul Cézanne. Experiments with tonal effects, light, mass, and other qualities in more than 100 drawings. A revealing view of developing master painter, precursor of cubism. 102 illustrations. 144pp. 8¾ x 6¾. 0-486-24790-2

GRAPHIC WORKS OF GEORGE CRUIKSHANK, George Cruikshank (Richard A. Vogler, ed.). 269 permission-free illustrations (8 in full color) reproduced directly from original etchings and woodcuts. Introduction, notes. 200pp. 9⅜ x 12¼. 0-486-23438-X

DAUMIER: 10 GREAT LITHOGRAPHS, Honoré Daumier. Works range from early and caustic anti-government drawings in 1831 to last works prior to retirement in 1872. Collection concentrates on liberated women, the French bourgeoisie, actors, musicians, soldiers, teachers, lawyers, married life, and myriad other creations by the "Michelangelo of the people." 158pp. 9⅜ x 12¼.
0-486-23512-2

DEGAS' DRAWINGS, H. G. E. Degas. Dancers, nudes, portraits, travel scenes, and other works in inimitable style, most not available anywhere else. 100 plates, 8 in color. 100pp. 9 x 12. 0-486-21233-5

THE DORÉ BIBLE ILLUSTRATIONS, Gustave Doré. 241 detailed plates from the Bible: the Creation scenes, Adam and Eve, horrifying visions of the Flood, the battle sequences with their monumental crowds, depictions of the life of Jesus, and visions of the new Jerusalem. Each plate is accompanied by the appropriate verses from the King James version. 241pp. 9 x 12.

0-486-23004-X

THE DORÉ GALLERY: HIS 120 GREATEST ILLUSTRATIONS, Gustave Doré (Carol Belanger Grafton, ed.). Comprising the finest plates from the great illustrator's work, this collection features outstanding engravings from such literary classics as Milton's *Paradise Lost, The Divine Comedy* by Dante, Coleridge's *The Rime of the Ancient Mariner, The Raven* by Poe, Sue's *The Wandering Jew,* and many others. Captions. 128pp. 9 x 12. 0-486-40160-X

DORÉ'S ANGELS, Gustave Doré. Dozens of the renowned artist's celestial beings, as created for such great literary works as the Bible, Coleridge's *The Rime of the Ancient Mariner,* and Milton's classic, *Paradise Lost.* 75 b/w illustrations. 80pp. 9 x 12. 0-486-43668-3

DORÉ'S ILLUSTRATIONS OF THE CRUSADES, Gustave Doré. Magnificent compilation of all 100 original plates from Ichaud's classic *History of the Crusades.* Includes *The War Cry of the Crusaders, The Massacre of Antioch, The Road to Jerusalem, the Baptism of Infidels, the Battle of Lepanto,* and many more. Captions. 112pp. 9 x 12. 0-486-29597-4

DORÉ'S ILLUSTRATIONS FOR DON QUIXOTE, Gustave Doré. Here are 190 wood-engraved plates, 120 full-page: charging the windmill, traversing Spanish plains, valleys, and mountains; ghostly visions of dragons, knights, and flaming lake. Marvelous detail, minutiae, accurate costumes, architecture, enchantment, pathos, and humor. Captions. 160pp. 9 x 12. 0-486-24300-1

THE RIME OF THE ANCIENT MARINER, Gustave Doré and Samuel Taylor Coleridge. Doré's dramatic engravings for *The Rime of the Ancient Mariner* are considered by many to be his greatest work. The terrifying space of the open sea, the storms and whirlpools of an unknown ocean, the ice of the Antarctica, and more—all are rendered in a powerful manner. Full text. 38 plates. 77pp. 9¼ x 12. 0-486-22305-1

GAUGUIN'S INTIMATE JOURNALS, Paul Gauguin. Revealing documents, reprinted from rare, limited edition, throw much light on the painter's inner life, his tumultuous relationship with van Gogh, evaluations of Degas, Monet, and other artists; hatred of hypocrisy and sham, life in the Marquesas Islands, and much more. 27 full-page illustrations by Gauguin. Preface by Emil Gauguin. 160pp. 6½ x 9¼. 0-486-29441-2

NOA NOA: THE TAHITIAN JOURNAL, Paul Gauguin. Celebrated journal records the artist's thoughts and impressions during two years he spent in Tahiti. Compelling autobiographical fragment. 24 b/w illustrations. 96pp. 5⅜ x 8½. 0-486-24859-3

THE DISASTERS OF WAR, Francisco Goya. 83 etchings record horrors of Napoleonic wars in Spain and war in general. Reprint of first edition, plus 3 additional plates. 97pp. 9⅜ x 8¼. 0-486-21872-4

LOS CAPRICHOS, Francisco Goya. Considered Goya's most brilliant work, this collection combines corrosive satire and exquisite technique to depict 18th-century Spain as a nation of grotesque monsters sprung up in the absence of reason. Captions. 183pp. 6⅜ x 9⅜. 0-486-22384-1

GREAT BALLET PRINTS OF THE ROMANTIC ERA, Parmenia Migel. Sumptuous collection from 1830 to 1860. Taglioni, Elssler, Grisi, and other stars by such artists as Chalon, Grevedon, Deveria, etc. Introduction. 128pp. 9 x 12. 0-486-24050-9

ORNAMENTATION AND ILLUSTRATIONS FROM THE KELMSCOTT CHAUCER, William Morris. Beautiful permission-free tailpieces, decorative letters, elaborate floral borders and frames, samples of body type, and all 98 delicate woodcut illustrations. xiv+112pp. 8½ x 12. 0-486-22970-X

WILLIAM MORRIS ON ART AND SOCIALISM, William Morris (Norman Kelvin, ed.). This outstanding collection of 11 lectures and an essay, delivered between 1881 and 1896, illustrates Morris' conviction that the primary human pleasure lies in making and using items of utility and beauty. Selections include: "Art: A Serious Thing," "Art Under Plutocracy," "Useful Work vs. Useless Toil," "The Dawn of a New Epoch," "Of the Origins of Ornamental Art," "The Society of the Future," and "The Present Outlook of Socialism." Introduction. Biographical Note. 208pp. 5⅜ x 8½. 0-486-40904-X

THE RENAISSANCE: STUDIES IN ART AND POETRY, Walter Pater. One of the most talked-about books of the 19th century, *The Renaissance* combines scholarship and philosophy in an innovative work of cultural criticism that examines the achievements of Botticelli, Leonardo, Michelangelo, and other artists. "The holy writ of beauty."–Oscar Wilde. vi+154pp. 5⅜ x 8½.

0-486-44025-7

GREAT LITHOGRAPHS BY TOULOUSE-LAUTREC: 89 PLATES, H. Toulouse-Lautrec. Exceptional sampling of some of finest lithographs ever. 89 plates, including 8 in full color. 88pp. 9⅜ x 12¼. 0-486-24359-1

A TOULOUSE-LAUTREC SKETCHBOOK, Henri de Toulouse-Lautrec. A superb draftsman whose work—especially his sketches—was graphic in nature, Toulouse-Lautrec produced art of striking originality and power. This little-known volume includes 85 of his most striking early efforts, the majority of them studies of horses. 112pp. 8¾ x 6¾. 0-486-43377-3

RENOIR: AN INTIMATE RECORD, Ambroise Vollard. Art dealer and publisher Vollard's splendid portrait of Renoir emerges in a long series of informal conversations with the Impressionist master that reveal intimate details of his life and career. 19 black-and-white illustrations of Renoir's paintings. 160pp. 5⅜ x 8½. 0-486-26488-2

Twentieth-Century Art

FRENCH SATIRICAL DRAWINGS FROM "L'ASSIETTE AU BEURRE," Stanley Appelbaum (ed.). 170 biting, original drawings (8 in full color) from French magazine with an unsurpassed style. Works by Steinlen, Cappiello, Caran d'Ache, Willette, Poulbot, Forain, Vallotton, and Robida–as well as Juan Gris, Jacques Villon, Kees van Dongen, and Frantisek Kupka. 183pp. 9⅜ x 12¼.
0-486-23583-1

THE VIBRANT METROPOLIS: 88 LITHOGRAPHS, George W. Bellows (selected by Carol Belanger Grafton). Brilliantly executed, richly evocative works by one of the most popular American artists of the early 20th century include *Nude in a Bed, Evening; In the Subway; Dempsey Through the Ropes;* and *Base Hospital,* among others. 96pp. 8⅜ x 11.
0-486-42304-2

CHAGALL DRAWINGS: 43 WORKS, Marc Chagall. Superb treasury of images by one of the most distinctive and original artists of the 20th century–from fanciful fiddlers hovering above rooftops to imaginatively conceived depictions of bareback riders and other circus performers. Includes, among other masterworks, *Wounded Soldier, Three Acrobats, Child on a Chair, Nude with a Fan, Peasants in Vitebsk,* and *The Magician.* 48pp. 8¼ x 11.
0-486-41222-9

DRAWINGS FOR THE BIBLE, Marc Chagall. 136 works, 24 in full color, depicting Old Testament subjects. Captions cite the biblical sources of each drawing. Reprinted from a rare double issue of the French arts magazine *Verve.* Publisher's Note. 136pp. 9¼ x 12¼.
0-486-28575-8

50 SECRETS OF MAGIC CRAFTSMANSHIP, Salvadore Dalí. Rare, important volume in which Dalí expounds (in his inimitably eccentric fashion) on what painting should be, the history of painting, what is good and bad painting, the merits of specific artists, and more. Includes his 50 "secrets" for mastering the craft, including "the secret of the painter's pointed mustaches." Filled with sensible artistic advice, lively personal anecdotes, academic craftsmanship, and the artist's own marginal drawings. 192pp. 9¼ x 12⅛. (Available in U.S. only)
0-486-27132-3

MODERN ARTISTS ON ART: SECOND ENLARGED EDITION, Robert L. Herbert (ed.). Sixteen of the 20th century's leading artistic innovators talk forcefully about their work–from Albert Gleizes and Jean Metzinger's 1912 presentation of cubist theory to Henry Moore's comments, three decades later, on sculpture and primitive art. Four newly added essays by Kurt Schwitters, Max Ernst, El Lissitzky, and Fernand Léger. 192pp. 5⅜ x 8½.
0-486-41191-5

HOPPER DRAWINGS, Edward Hopper. 44 plates, reproduced directly from originals in the collection of the Whitney Museum of American Art, reveal Hopper's superb draftsmanship and evocative power. Only book devoted exclusively to Hopper's drawings. 48pp. 8¼ x 11⅛.
0-486-25854-8

100 DRAWINGS, Gustav Klimt. The finest drawings of the celebrated Austrian artist–mostly nudes and seminudes taken in part from rare portfolios of 1919 and 1964–reveal the dynamics of the line in representing the human figure spontaneously and freely. Introduction. 99pp. 9⅜ x 12¼.
0-486-22446-5

THE SPIRITUAL IN TWENTIETH-CENTURY ART, Roger Lipsey. Compelling and well-illustrated, this study focuses on the works of such renowned painters as Kandinsky, Mondrian, Klee, Picasso, Duchamp, and Matisse. The eloquent text offers insights into the artists' views of spirituality and their approach to work as a form of meditation. 121 black-and-white illustrations. xxvi+518pp. 5⅜ x 8½.
0-486-43294-7

THE ART NOUVEAU STYLE: A Comprehensive Guide with 264 Illustrations, Stephan Tschudi Madsen. Absorbing, exceptionally detailed study examines early trends, posters, and book illustrations, stylistic influences in architecture; furniture, jewelry, and other applied arts; plus perceptive discussions of artists associated with the movement. 488pp. 6½ x 9¼.
0-486-41794-8

THE NON-OBJECTIVE WORLD: THE MANIFESTO OF SUPREMATISM, Kasimir Malevich. One of the 20th century's most profound statements of aesthetic theory, this work defined the artist's radical, non-objective style, which he referred to as Suprematism (the preeminence of emotion in creating works of art). Included here among Malevich's most famous works is the 1913 painting *Black Square on White.* 92 b/w illustrations. 102pp. 8⅜ x 11.
0-486-42974-1

MIRÓ LITHOGRAPHS, Joan Miró. 40 important lithographic prints with line and composition comparable to Miró's friend Picasso. Eerie, droll, technically brilliant and aggressive. 48pp. 8¼ x 11⅛.
0-486-24437-7

DRAWINGS OF MUCHA, Alphonse Mucha. 70 large-size illustrations trace Mucha's draftsmanship over more than 40 years: original plans and drawings for "The Seasons," Sarah Bernhardt posters, etc., all displaying marvelous technique. Introduction. 75pp. 9⅜ x 12¼.
0-486-23672-2

MUCHA'S FIGURES DÉCORATIVES, Alphonse Mucha. Figures of women, young girls, and children of both sexes in inimitable style of Art Nouveau master. His last stylebook. 40 plates in original color. 48pp. 9⅜ x 12¼.
0-486-24234-X

GRAPHIC WORKS OF EDVARD MUNCH, Edvard Munch. 90 haunting, evocative prints by first major Expressionist artist: *The Scream, Anxiety, Death Chamber, The Kiss, Madonna on the Jetty, Picking Apples, Ibsen in the Cafe of the Grand Hotel,* etc. xvii+90pp. 9 x 12.
0-486-23765-6

JOSÉ CLEMENTE OROZCO: AN AUTOBIOGRAPHY, José Clemente Orozco. Wealth of insights about great muralist's first inspirations; reflections on his life, on Mexico, on mural paintings; his relationships with other painters, and experiences in the United States. 192pp. 5⅜ x 8¼.
0-486-41819-7

OPTICAL ART: Theory and Practice, Rene Parola. First complete explanation of influential artistic movement: visual perception, psychological phenomena, principles and applications of Op Art, and more. Over 180 illustrations. 144pp. 9 x 12.
0-486-29054-9

PICASSO LINE DRAWINGS AND PRINTS, Pablo Picasso. 44 works from many periods and styles show 1905 circus family, portraits of Diaghilev, Balzac, Cubist studies, etc. 48pp. 8¼ x 11⅛.
0-486-24196-3

PICASSO LITHOGRAPHS, Pablo Picasso. 61 works over a period of 35 years. Master artist/craftsman revels in bulls, nudes, myth, artists, actors–all in the purest lithographic line. 64pp. 8¼ x 11⅛.
0-486-23949-7

THE COMPLETE GRAPHIC WORK OF JACK LEVINE, Kenneth W. Prescott and Emma Stina-Prescott.. Never-before-published prints of work by major American artist/social commentator. Plate-by-plate commentaries. 84 works in all. 112pp. 9⅜ x 12¼.
0-486-24481-4

RACKHAM'S COLOR ILLUSTRATIONS FOR WAGNER'S RING, Arthur Rackham. By the time he began this work, Rackham (1867–1939) was England's leading illustrator, famous throughout the world for his fantastic interpretations of fairy tales and myths. This, his masterpiece, is regarded by some as the greatest representation of Wagner's drama ever produced. 64 illustrations. 9 vignettes. 72pp. 8⅜ x 11⅛.
0-486-23779-6

RACKHAM'S FAIRY TALE ILLUSTRATIONS IN FULL COLOR, Arthur Rackham (selected and edited by Jeff Menges). Superb collection of 55 lovely plates, reproduced from rare, early editions; scenes from *Irish Fairy Tales, English Fairy Tales, Hansel and Gretel, Snowdrop and Other Tales, Little Brother & Little Sister,* and others. 64pp. 8 x 11¼.
0-486-42167-8

PHOTOGRAPHS BY MAN RAY: 105 WORKS, 1920–1934, Man Ray. Here is a treasury of Ray's finest photographic work, arranged in five groupings: general subject, female figures, women's faces, celebrity portraits, and rayographs ("cameraless" compositions, created by resting objects on unexposed film). 105 photos, including one in color. Texts by Ray and others. 128pp. 9⅜ x 12¼.
0-486-23842-3

SCHIELE DRAWINGS: 44 WORKS: Egon Schiele. Treasury of portraits, character studies, nudes, and more, by great Viennese Expressionist. Characteristic focus on inner psychological states and hidden personality traits of subjects. 48pp. 8¼ x 11⅛.
0-486-28150-7

CAMERA WORK: A PICTORIAL GUIDE, Alfred Steiglitz (edited by Marianne Fulton Margolis). The most important periodical in the history of art photography was *Camera Work,* edited and published by Alfred Stieglitz from 1903 to 1917. This volume contains all 559 illustrations that ever appeared in its pages, including hundreds of important photographs by the preeminent photographers of the time: Eduard Steichen, Alfred Stieglitz, Paul Strand, Alvin Langdon Coburn, Clarence White, and many others. 176pp. 8⅜ x 11¼.
0-486-23591-2

STEINLEN CATS, Théophile-Alexandre Steinlen. 66 drawings and 8 picture stories of great illustrator's favorite study–cats! 48pp. 8¼ x 11⅛.
0-486-23950-0

GODS' MAN: A NOVEL IN WOODCUTS, Lynd Ward. A powerful, passionate novel–told entirely through 139 intricate woodcuts–artist Lynd Ward invented the concept of a wordless novel with this autobiographical account of his struggles with his craft and with life in the 1920s. Top-quality, low-cost republication of a longtime collectors' item. 160pp. 6⅛ x 9¼.
0-486-43500-8

Art and Design from Many Cultures

AMERICAN INDIAN DESIGN AND DECORATION, Leroy Appleton. Full text, plus more than 700 precise drawings of basketry, sculpture, painting, pottery, sand paintings, metal, etc. 4 plates in color. 279pp. 8⅜ x 11. 0-486-22704-9

PRIMITIVE ART, Franz Boas. America's foremost anthropologist surveys textiles, ceramics, woodcarving, basketry, metalwork, etc. All areas of the world, but very full on Northwest Coast Indians. More than 350 illustrations of baskets, boxes, totem poles, weapons, etc. 378pp. 5⅜ x 8½. 0-486-20025-6

IDOLS BEHIND ALTARS: MODERN MEXICAN ART AND ITS CULTURAL ROOTS, Anita Brenner. Critical study ranges from pre-Columbian times through the 20th century to explore Mexico's intrinsic association between art and religion; the role of iconography in Mexican art; and the return to native values. Unabridged reprint of the classic 1929 edition. 117 b/w illustrations. 432pp. 5⅜ x 8½. 0-486-42303-4

THE DANCE OF SIVA, Ananda K. Coomaraswamy. Preeminent authority unfolds the vast metaphysics of India: the revelation of her art, conception of the universe, social organization, etc. 27 reproductions of art masterpieces. 192pp. 5⅜ x 8½. 0-486-24817-8

DESIGN MOTIFS OF ANCIENT MEXICO, Jorge Enciso. Vigorous, powerful ceramic stamp impressions–Maya, Aztec, Toltec, Olmec, Serpents, gods, priests, dancers, etc. 153pp. 6⅛ x 9¼. 0-486-20084-1

DESIGNS FROM PRE-COLUMBIAN MEXICO, Jorge Enciso. 300 bold, rhythmic circle designs incorporating deities, reptiles, birds, flowers, masks, and geometrics. 105pp. 6⅛ x 9¼. 0-486-22794-4

ARGENTINE INDIAN ART, Alejandro Eduardo Fladone. This stunning collection of 284 rare designs is a bonanza for artists and craftspeople seeking distinctive patterns with a South American Indian flavor: animal and totemic designs, geometric and rectilinear figures, abstracts, grids, and many other styles in a wide range of shapes and sizes. 96pp. 8⅜ x 11. 0-486-29896-5

AN AZTEC HERBAL: THE CLASSIC CODEX OF 1552, William Gates (ed.). Originally written in the Aztec language, this 16th-century codex was the first herbal and medical text compiled in the New World. A rare and valuable document–amazing in its scope and detail–it contains ancient remedies for myriad ailments: boils, hearing loss, cataracts, insomnia, hiccoughs, and gout, to name a few. Analytical index to plants. More than 180 b/w, 38 color illustrations. 192pp. 5⅜ x 8½. 0-486-41130-3

THE GODS OF NORTHERN BUDDHISM: THEIR HISTORY AND ICONOGRAPHY, Alice Getty. Invaluable reference covers names, attributes, symbolism, and representations of deities in Mahayana pantheon of China, Japan, Tibet, etc. 185 illustrations. 352pp. 6½ x 9¼. (Available in U.S. only) 0-486-25575-1

MEXICAN PAINTERS, MacKinley Helm. Definitive introduction to the art and artists of Mexico during great artistic movements of the 1920s and 1930s. In-depth discussion of major figures–Diego Rivera, Jose Clemente Orozco, and David Alfaro Siqueiros–as well as 40 other artists: Galvan, Cantú, Mexa, and more. 95 illustrations. 228pp. 6½ x 9¼. 0-486-26028-3

PUEBLO DESIGNS: THE "RAIN BIRD," H. P. Mera. 48 plates, 26 in 2 colors, show beautiful, useful Indian motif–thunderbird–from early times to the present. Tribal variations. 176 illustrations. 113pp. 7¼ x 10¼. 0-486-22073-7

ARABIC DESIGNS, Gregory Mirow. For graphic artists, designers, and enthusiasts of Arabic art–scores of elegant motifs, among them florals from ancient Persian fabrics, star-shaped thirteenth-century tiles from Iran, and a detail from a painting of Mecca and Medina (18th–19th century). 165 b/w designs. Identifications. 32pp. 8¼ x 11. 0-486-42171-6

AUTHENTIC INDIAN DESIGNS, Maria Naylor (ed.). Largest collection anywhere: 2,500 authentic illustrations of pottery, beadwork, blankets, totem poles, metal, hide paintings, baskets, and much more. 219pp. 8¼ x 11. 0-486-23170-4

SANDPAINTINGS OF THE NAVAJO SHOOTING CHANT, Franc J. Newcomb and Gladys A. Reichard. A classic of ethnology, reproducing in full color 35 sandpaintings from this important Navajo healing ceremony, and analyzing the symbolism and myth they express. 132pp. 9¼ x 12. 0-486-23141-0

THE CODEX NUTTALL, Zelia Nuttall (ed.). Only inexpensive edition, in full color, of a pre-Columbian Mexican (Mixtec) book. 88 color plates show kings, gods, heroes, temples, sacrifices, and more. New introduction by Arthur G. Miller. 96pp. 11⅜ x 8½. 0-486-23168-2

IDEALS OF THE EAST: THE SPIRIT OF JAPANESE ART, Kakuzo Okakura. Written by the author of *The Book of Tea*, this extremely influential book offers a brief but concise introduction to Asian art. First published in 1883, it provided the earliest lucid English-language account of Zen Buddhism and its relation to the arts, and its appreciations of Japanese artistic expressions of beauty and philosophy remain fresh and valid. xxii+74pp. 5⅜ x 8½. 0-486-44024-9

SOUTHWESTERN INDIAN DESIGNS, Madeleine Orban-Szontagh. Treasury of 250 authentic motifs drawn from Navajo jewelry and rugs, Pueblo pottery, Hopi ceremonial dress, and other sources. 48pp. 8¼ x 11. 0-486-26985-X

EGYPTIAN DECORATIVE ART, W. M. Flinders Petrie (ed.). Classic study of the historical development of Egyptian decorative art examines Egyptian taste in decorating, ornamental writing of hieroglyphs, origin of patterns, and more. Over 200 carefully drawn figures illustrate types of decoration under discussion: zigzags, waves, spirals, feathers, rosettes, lotus blossoms, basket work, cornices, gods and goddesses, the scarab, and much else. x+128pp. 5⅜ x 8. 0-486-40907-4

AFRICAN SCULPTURE, Ladislas Segy. 164 photographic plates of masks, votive figures, metalwork, and carvings, with long introduction. Ashanti, Yoruba, Benin, etc. 244pp. 6 x 9. 0-486-20396-4

MASKS OF BLACK AFRICA, Ladislas Segy. 247 photographs of masks–identified by tribe, place, and ritual use–include Dogon, Senufo, and many more. Text plus 21 photos of masks in dance. 248pp. 8¼ x 11. 0-486-23181-X

DECORATIVE ART OF THE SOUTHWESTERN INDIANS, Dorothy S. Sides. Beautiful primitive art in nearly 300 permission-free examples. Includes designs from pottery, basketry, beadwork, masks, dolls, sand paintings, and blankets. 101pp. 5⅜ x 8½. 0-486-20139-2

A STUDY OF MAYA ART: ITS SUBJECT MATTER AND HISTORICAL DEVELOPMENT, Herbert J. Spinden. Landmark classic interprets Maya symbolism, estimates styles, covers ceramics, architecture, murals, and stone carvings as art forms. More than 750 illustrations. 341pp. 8⅜ x 11¼. 0-486-21235-1

CHINESE ARCHITECTURE: A PICTORIAL HISTORY, Liang Ssu-ch'eng. More than 240 rare photographs and drawings depict temples, pagodas, tombs, bridges, and imperial palaces comprising much of China's architectural heritage. 152 halftones, 94 diagrams. xxv+201pp. 10¾ x 9⅞. 0-486-43999-2

A GUIDE TO JAPANESE PRINTS AND THEIR SUBJECT MATTER, Basil Stewart. British connoisseur describes in detail the subject of famous Japanese color prints using 274 reproductions of works by Hokusai, Hiroshige, Utamaro, Shunyei, and other masters. Bibliography. Index. 576pp. 6⅜ x 10. 0-486-23809-1

AFRICAN DESIGN: AN ILLUSTRATED SURVEY OF TRADITIONAL CRAFTWORK, Margaret Trowell. Nearly 200 handsome illustrations–from repetitive motifs in fabrics to carvings on bowls, drinking vessels, and door panels. Each object is identified and tribal source cited. 197 b/w illustrations. 156pp. 8⅜ x 11. 0-486-42714-5

MAYA DESIGNS, Wilson G. Turner. More than 40 authentic Maya designs–details from murals, vases, codexes, instruments, glyphs, etc.–all with informative captions. 48pp. 8¼ x 11. 0-486-24047-9

OUTLINES OF CHINESE SYMBOLISM AND ART MOTIVES, C. A. S. Williams. Standard reference long familiar to students of Chinese culture emphasizes historical, legendary, or supernatural persons, animals, and objects as symbols in art and literature. 402 illustrations. 472pp. 5⅜ x 8½. 0-486-23372-3

NORTH AMERICAN INDIAN DESIGNS FOR ARTISTS AND CRAFTSPEOPLE, Eva Wilson. More than 360 authentic permission-free designs adapted from Navajo blankets, Hopi pottery, Sioux buffalo hides, and more. Geometrics, symbolic figures, plant and animal motifs, etc. 128pp. 8⅜ x 11. (Not available in the United Kingdom). 0-486-25341-4

*Write for **free** Fine Art and Art Instruction Catalog to*
Dover Publications, Inc., Dept. ABI, 31 East 2nd Street, Mineola, NY 11501
*Visit us online at **www.doverpublications.com***